P9-CIV-941

kawaii polymer
# clay creations

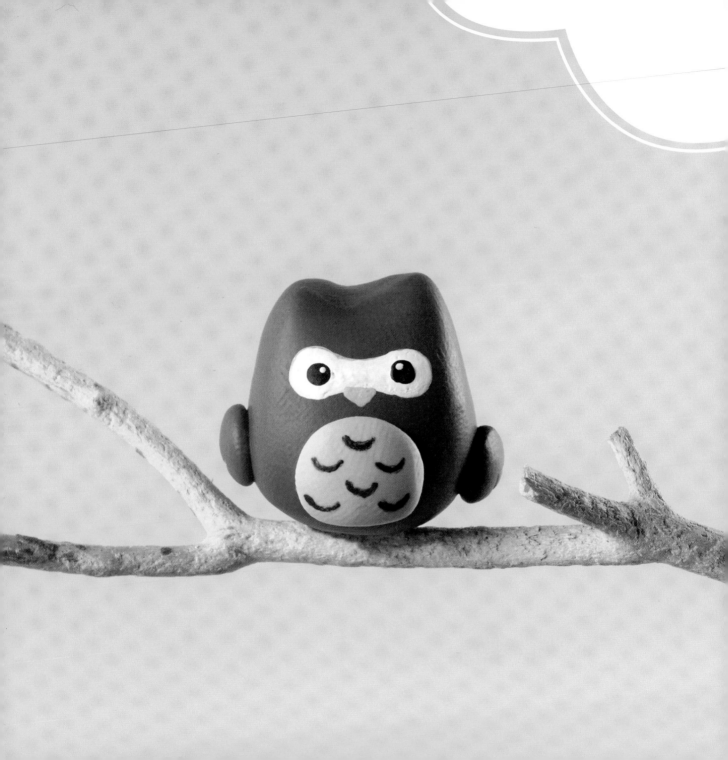

# kawaii polymer
# clay creations

## 20 super-cute miniature projects

### .: emily chen :.

Fons&Porter

CINCINNATI, OHIO

# contents

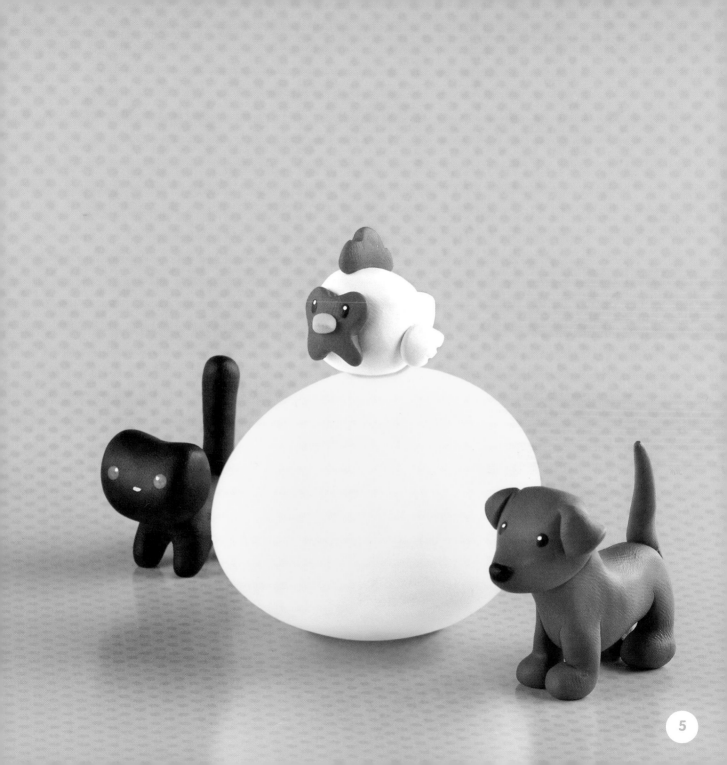

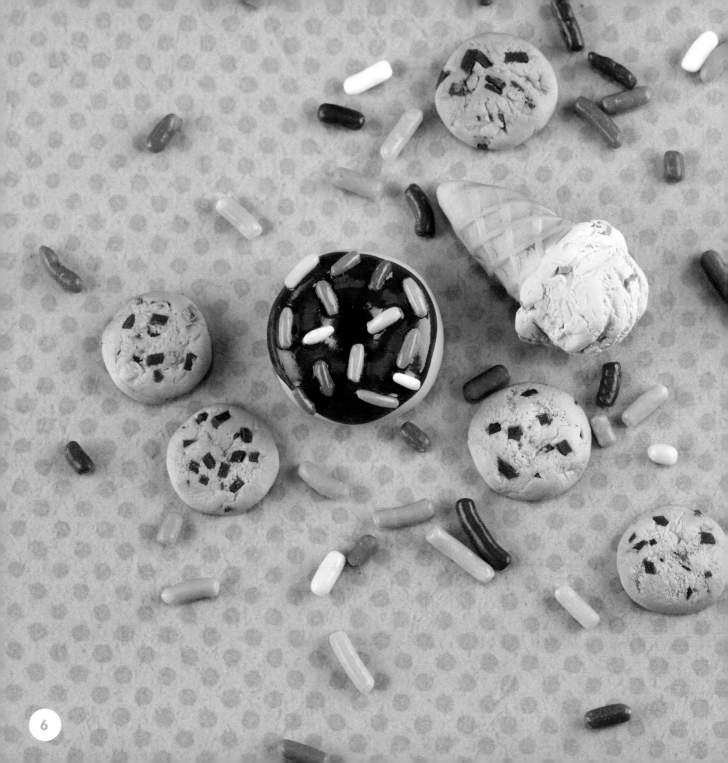

# introduction

Welcome to the world of polymer clay! I have worked with polymer clay for more than ten years now and continue to learn new things every day. It's a versatile material that anyone can work with, even without any kind of formal schooling or training. Whether it be miniature foods, animals or imaginary creatures, the sky's the limit when it comes to what you can create with polymer clay.

Most of the projects in this book are inspired by Japanese *kawaii*, or "cute," culture. The projects are meant to teach you some polymer clay basics and beginner techniques that will hopefully inspire you to design your own cute clay creations.

# materials and tools

In this chapter, I will introduce you to the materials and tools that we will work with in the projects that follow. All of these items are widely available at craft stores and online, but if you cannot find a specific tool, do not fret! Many tools can be replaced with household objects.

## Materials

**Polymer Clay:** Polymer clay is a versatile modeling material made from polyvinyl chloride (PVC) that remains malleable until it is cured in an oven. It comes in a wide variety of colors and can be combined to make any color you can imagine.

A large variety of polymer clay is available on the market. Three of the most popular brands are Sculpey III, Premo! Sculpey and FIMO. All of these are available at your local arts and crafts store or can be found online. Other available brands of polymer clay include Cernit, Kato Polyclay, Pardo, Formello, Modello and Du-kit. As polymer clay becomes more popular, stores are beginning to stock a wider variety of brands, so keep an eye out for these in the future.

When purchasing clay, feel different packages of the same color to compare the softness of the clay. Try to pick the softest clay, as it is easier to work with than harder clay. Some brands start out hard as a brick, and these need to be conditioned before use. Different brands and even different colors within a brand vary in softness and finish strength. Furthermore, weather (especially humidity) can affect how the clay feels.

Sculpey III is the cheapest of the brands listed and is good for children or beginners who don't want to invest too much money.

FIMO and Premo! Sculpey are both pretty strong, and the projects in this book are all made using a combination of these two brands.

Play around with different brands to see which ones you prefer and what works best where you live.

**Liquid Polymer Clay:** Liquid polymer clay can be used for some interesting techniques, such as creating image transfers, baking separate pieces together and even glazing. (This is different from bakeable adhesive products made especially for bonding, such as Bake & Bond.) Liquid polymer clay is available from Sculpey, Kato Polyclay and FIMO. In this book we will be using liquid clay to create realistic textures for cake frosting and peanut butter and jelly sandwiches.

**Acrylic Paint:** Water-based acrylic paints can be used on finished polymer clay pieces to add details. Any quality water-based acrylic will work well on the clay.

**Chalk Pastels:** Chalk pastels are great for adding soft color to polymer clay and liquid clay. You can buy pastels individually or in packs in a variety of colors. Either scrape off a bit of the pastel when you need it or store the pastel powder in small containers for quick access. Use a small, soft brush to apply the pastels to unbaked clay.

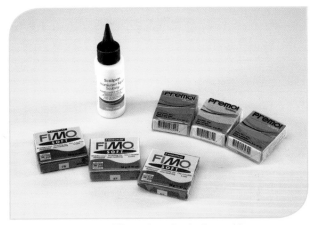

Polymer clay comes in different brands, shades and forms.

### .: clay too sticky or too hard? :.

Although clay does not go bad, it can become hard after years of sitting on the shelf. If your clay is too hard, add some clay softener (found in craft stores) or mix it with softer clay. You can also add some liquid clay or a tiny bit of baby oil.

If your clay is too soft, mix it with harder clay or leach the clay. To do this, roll out a thin layer and place it between two sheets of plain white paper for a few hours. The paper will soak up some of the plasticizer in the clay, making it less soft. Alternatively, you can place it in the freezer for a few minutes until it becomes hard enough to work with.

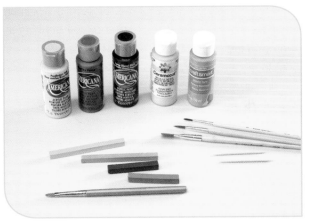

Water-based acrylic paints can be used to detail finished pieces, and chalk pastels provide subtle color when applied prior to baking. Use toothpicks for small details and brushes for applying pastel powders or larger paint details.

**Glues and Adhesives:** There's a huge variety of glue and adhesive on the market. In the end, choosing one comes down to personal preference. Super Glue, epoxy glue or E6000 glue are all strong adhesives that will work on polymer clay. Use glue to make repairs if something falls off after baking and to glue in eye pins or attach your pieces to jewelry.

**Glaze or Finish:** Glazes are available from FIMO, Sculpey and Kato Polyclay, but any kind of water-based polyurethane finish can be used for finishing your polymer clay pieces. The hardware store is a great place to find cans of finishes for lower prices.

**Wire:** Wire is used for reinforcing delicate parts of a project and for making jewelry. Use 18- or 20-gauge wire in any color.

## Tools

**Work Surface:** A clean work surface is a necessity. A sheet of silicone like those used in baking, plexiglass or a smooth ceramic tile are all great surfaces to work on. Do not place uncured clay on wood or a varnished surface! The plasticizer in the clay will eat away at the varnish and wood, so always protect these surfaces.

**Oven:** You will need an oven to cure your finished pieces. Although a regular kitchen oven or toaster oven can be used, it is best to have an oven dedicated to baking clay.

Although polymer clay is labeled non-toxic, I recommend taking a few safety precautions. If curing in a kitchen oven, put your piece on a baking sheet and cover the piece with aluminum foil. If you notice an odor coming

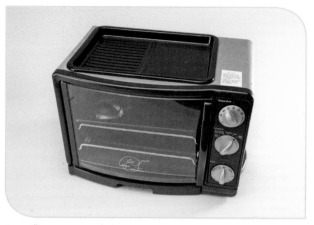

A small toaster oven dedicated to clay is a good, inexpensive investment. Keep a thermometer in the oven as internal temperatures can vary.

from the oven, check to be sure the clay piece is completely covered. Any trays or sheets used for polymer clay should not be used for anything else. Additionally, clean the kitchen oven thoroughly before using it for food (many ovens have self-clean settings that will take care of it for you).

Most polymer clay cures at 275°F (135°C) or 215°F (102°C), but it is important to check the instructions on the package of clay for exact temperatures and baking times.

**Piercing Tool:** A piercing tool is used to create small details and textures. If you cannot find the tool, a straight pin typically used in sewing is a great substitute and does the job just as well.

Tiles are inexpensive work surfaces that clay won't stick to. Blades and sculpting tools are used for detail work and come in packs at the craft store.

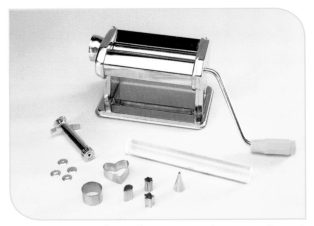

Tools like a pasta machine, roller, extractor and stamps can be used to create interesting pieces.

**Blade:** Polymer clay blades are available in craft stores and come in both flexible and rigid options. These blades are sharp, so be careful when handling them. If you cannot find a polymer clay blade, a craft knife or razor blade works, too.

**Shape Cutters:** A number of small shape cutters are available in craft stores. Cookie cutters can also be used, which means you have a great variety to choose from. Basic shapes like circles, triangles and squares are very useful, and cookie cutters are wonderful for creating fake cookies or flat charms.

**Clay Extruder:** Clay extruders are available in the clay section of craft stores and come with interchangeable plates of different shapes. This tool can be used for creating uniform shapes like round snakes, squares, rectangles and more.

**Icing Tips:** Icing or decorating tips used for cakes can also be used with clay. Generally you'll want the smallest size available, and the tips should be dedicated for clay use only.

**Clay Roller:** A clay roller is extremely useful for rolling out sheets of polymer clay and for conditioning or mixing clay. If you cannot find one, check the house for a tube made of plastic, glass or metal. The handle of a craft knife works well as a small roller—just be sure to remove the blade first!

**Pasta Machine:** A pasta machine requires a greater investment, but it will make your work a lot easier. It can be used for mixing colors, conditioning and rolling out sheets of clay. The pasta machine should be dedicated to clay only and should not be used for food.

# polymer clay basics

This chapter covers a few techniques that you will need to know before you start. You'll use these techniques each time you work with polymer clay, so it pays to learn them well.

### Conditioning Clay

Properly conditioning clay makes it easier to work with and creates a stronger finished piece. The easiest way to condition clay is by kneading it with your hands. Alternate between rolling the clay out into long snakes and squishing it into a ball until it is malleable.

Some clay is easier to condition than others. If you are having trouble with hard clay, use some clay softener (available in craft stores) to make working with it easier.

Air bubbles can cause problems in your finished piece, so it's especially important to avoid making them during the conditioning process. Pop any air bubbles with a pin or press them down with your fingers. If using a pasta machine, place the folded end of the clay into the machine or off to the side so that air can escape.

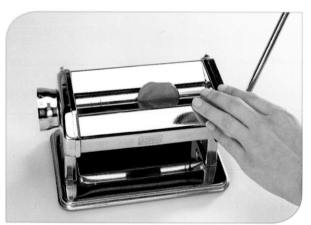

1 Roll the clay through the pasta machine. Flatten the clay first and don't use too much, as overloading can damage the roller.

2 Fold and continue to roll the clay until it's easy to work with your hands.

## Shaping Clay

The projects in this book use a few basic shapes. Here I explain what they are and how to make them.

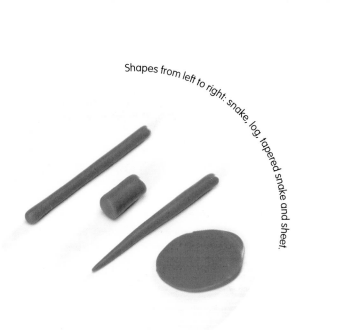

Shapes from left to right: snake, log, tapered snake and sheet.

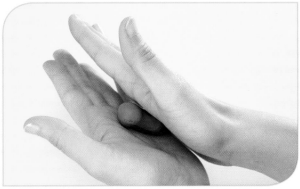

### LOG

A log will be fairly thick, approximately the thickness of your index finger. Use either your fingers or palms to roll the clay out on your work surface.

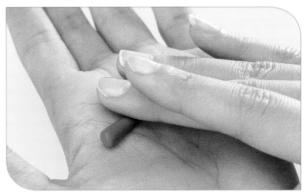

### SNAKE

Rolling out a snake of clay means creating a long tube that is fairly thin. As you roll, move your hand along the snake to ensure it has an even thickness all the way down.

## .: sticky hands :.

If your hands are sticking too much to the clay, dust them lightly with some cornstarch.

## .: even rolling :.

An easy way to make sure you create an even sheet when using a roller is to use playing cards. Make two piles of playing cards, each with the same number of cards, and place two rubber bands around each stack. Place your piece of clay in between these stacks and roll across the stacks and clay with your roller. The resulting sheet will be the same thickness as the stack of cards.

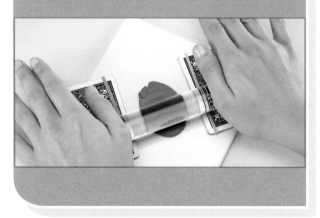

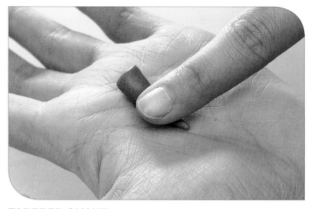

**TAPERED SNAKE**

A tapered snake is a snake that tapers to a point on one end. Create this shape by rolling a snake, then moving your finger from the center outward until you have one pointed end.

**SHEET**

A sheet is a flattened piece of clay. Create a sheet by using either a pasta machine or a roller.

When attaching two pieces of clay, smooth the seams with your finger.

When mixing colors, work with small amounts of clay first to figure out the ratio of colors; working in small batches makes the clay easier to manage.

### .: scrap clay and molds :.

If a piece of clay becomes very dirty or mixed with too many colors, do not fret! There are plenty of ways you can use scrap clay. Just mix all of your scrap clay together to create one uniform color and set it aside in a container for later use.

One such use for scrap clay is making molds that you can use again and again. Dust the item to be molded (such as a button) with cornstarch and press it into scrap clay. Remove the item and bake the clay. To use the mold, press clay into the mold and remove the clay before baking. For more on making and using molds, see pages 100–101 of the Strawberry Ice Cream Cone project.

## Smoothing Attached Pieces

When you want to smooth the area where two pieces of clay are joined, run your finger lightly over the clay until it blends together and you can no longer see where the two pieces are attached. Use this technique to get rid of unwanted fingerprints, lines and imperfections before baking, as well.

## Mixing Colors

Polymer clay comes in a variety of colors, but you can also create any color you want by mixing colors. Don't be afraid to play around and mix brands together to make new colors. If the brands you are mixing have different baking times and temperatures, bake at the lowest temperature for a longer period of time. Mix the clay the same way you would condition it, by squeezing and rolling it in your hands until the colors are completely combined. If you have a pasta machine, you can roll it through the machine until combined.

## Storing Clay

Although polymer clay does not dry out if left exposed, it does attract dirt and fuzz, so keeping it in a covered container is best. Wrap unused clay with plastic wrap or place it in a zippered plastic bag, then put it in a container. Bead storage containers are nice for clay storage, as they allow you to see all of your colors at once while keeping them separate.

## Baking

Polymer clay must be baked in an oven at a low temperature to cure. Bake the piece on a tile, silicone mat or baking sheet. If the bottom of the piece becomes shiny and you want a matte finish, line your baking sheet with a piece of parchment paper. It may take a few tries to figure out the best temperature to cook the clay. Having a separate thermometer in the oven is useful since the actual temperature inside the oven can vary from the display. Test a few balls of clay at different temperatures and for different lengths of time. If your piece comes out hard and shiny, the temperature is too high. If it is still soft and squishy, the temperature is too low.

Bead storage boxes or other small containers are great for keeping clay organized and lint-free. Look for boxes made of plastic, which will not react adversely with the clay.

### .: cracks :.

If you find small cracks in your baked piece, there's still hope to save it! While it's still hot, dip it into ice-cold water and squeeze the crack together for a minute or two. If your piece has already cooled down, simply pop it back into the oven until heated and then dip it in cold water.

### .: fingerprints :.

There's no way to completely get rid of fingerprints, but here are a few tips for minimizing them. Lightly rub your finger over any fingerprints to smooth out the clay. Use a cotton swab with a small amount of rubbing alcohol to get rid of tiny fingerprints, but be aware that alcohol can leave a streak and eat away at the clay if you use too much. One of the benefits of finishing pieces with glaze is that it makes fingerprints practically disappear, but if you don't like the shiny finish, try sanding it down with fine-grit sandpaper after baking. If all else fails, you can always wear a pair of latex gloves or finger cots (latex covers for individual fingers) while you work to eliminate fingerprints.

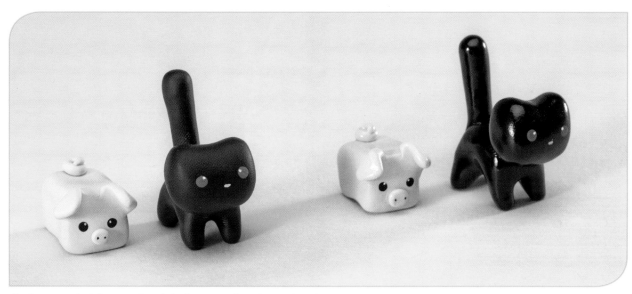

The figures on the left are unglazed; the figures on the right are glazed.

## Painting and Glazing

Baked clay can be detailed with water-based acrylic paints. Having a few brushes in different sizes is useful for creating a variety of effects with the paint. For small details like eyes and mouths, try a toothpick.

When glazing, it's best to apply thin layers multiple times. If you apply too much glaze at one time, it can pool up in crevices or at the bottom of the piece. If there are bubbles in the glaze, you can pop them by lightly blowing on the piece or popping them individually with a pin. Try to avoid wiping excess glaze from the brush onto the side of the container as this will cause more bubbles.

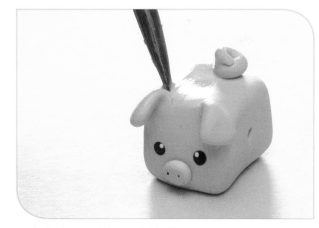

Apply thin layers of glaze to finished pieces to prevent the glaze from dripping.

## Embellishing With Liquid Polymer Clay

By adding different substances to liquid polymer clay, you vary the thickness of the liquid clay. By adding color to liquid clay with oil paints or chalk pastels, you can get a translucent clay color and still maintain the viscosity of the liquid.

Adding solid polymer clay to the liquid clay will result in a paste-like texture, which is perfect for creating icing on cakes or cookies.

Combine your chalk color or solid clay with the liquid clay in a small cup using a toothpick or a plastic knife to mix. You can also use a craft stick or a flat clay tool to mix them together. Store mixtures in containers for future use.

MIXING SOLID CLAY AND LIQUID CLAY

1 Mixing solid clay with liquid clay. Make a well in the solid clay and add liquid clay a little bit at a time.

2 Create a paste with solid and liquid clay for details like peanut butter or icing. Add more liquid clay if the mixture is too thick; add more solid clay if it becomes too runny.

## Using Chalk Pastels

Prepare chalk pastels for use by scraping the pastel with a cutting tool and making a powder. This powder can then be applied to unbaked clay to add subtle color to the piece. Use a soft paintbrush to apply the pastels. For any colors you use often, scrape them into a small container for easy access.

A second way to add color with chalk pastels is to mix the chalk powder with liquid clay. Just follow the steps below.

## Cleaning Up

Always wash up after working with clay. One of the best ways to clean clay from your hands is to use baby wipes. If clay remains on your hands, wash with soap and warm water. I like to finish with some hand lotion, as the clay can leave your hands a bit dry.

MIXING CHALK AND LIQUID CLAY

1 Add color to liquid clay by scraping chalk pastel.

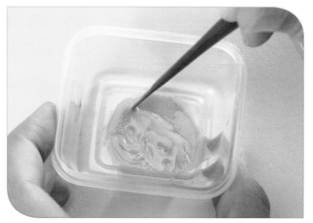

2 Stir to combine. Add more pastel until you're satisfied with the color saturation. Add more liquid if you want to lighten the color.

# jewelry-making techniques

Almost anything you make out of polymer clay can be turned into a piece of jewelry, be it a necklace or a pair of earrings. Here is a short overview of basic jewelry-making techniques to use with your projects.

    The techniques on this page and the next will allow you to turn any of the projects into a charm. A charm can be attached to a keychain, a necklace or almost anything else.

## Making an Eye Pin

Eye pins are essential for creating charms and jewelry. You can easily make them yourself with wire, pliers and a wire cutter. Wire comes in a variety of colors so pick whichever you think works best with the colors of the project. Either 18- or 20-gauge wire is recommended.

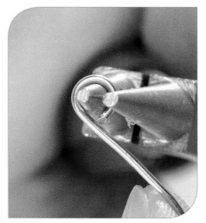

1 Using a pair of round-nose pliers, take hold of one end of the wire. Twist the wire around the pliers until you have a circle.

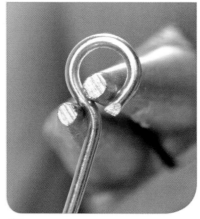

2 Twist the long part of the wire down slightly to make an eye pin. The long part is called the leg.

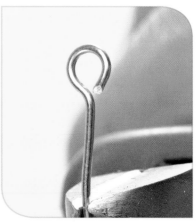

3 Cut the wire to your desired length, and you've made yourself an eye pin. Insert the eye pin into a clay piece before baking to turn it into a charm.

## INSERTING AN EYE PIN

Follow the steps below to insert an eye pin into your clay piece to make a charm. If the clay piece isn't big enough for you to insert the eye pin at an angle, as shown below, put the eye pin in and bake. Once it has cooled, take the eye pin out and place a dab of strong glue into the hole (see Chapter 1 for glues and adhesives). Place the eye pin back in the hole and let the glue set before using.

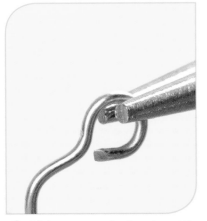

1 Make an eye pin, then bend the leg of the wire at a 90° angle.

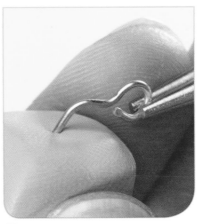

2 Insert the wire leg into your clay. If there is a long section of the piece, angle the wire to fit in that space.

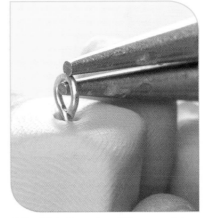

3 Slide the wire all the way into the clay. Think about which side will be the front and twist the eye pin around to the proper orientation. If the clay around the eye pin becomes too loose, carefully squeeze the clay to cover it up again. Additionally, you can put a dab of liquid clay into the hole before baking.

## MAKING A JUMP RING

Jump rings are used to attach charms to jewelry like necklaces or bracelets. You can change the thickness of the ring by wrapping the wire around different parts of the pliers. Alternatively, you can twist the wire around a dowel, pen or other round object.

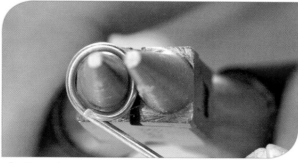

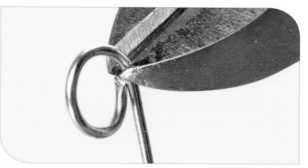

1 To make a jump ring, use the round-nose pliers to twist the wire around one of its prongs to create a circle.

2 Cut the wire so the ends come together to form a circle. Your jump ring is complete.

## Adding Beads to Wire

String beads on wire to use as embellishments for jewelry pieces. You can hang them next to clay charms or attach them to one another to make bracelets or necklaces.

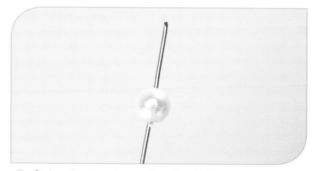

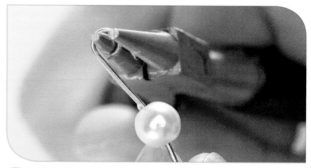

1 String the bead onto the wire; if the wire does not fit through the bead hole, use a thinner wire.

2 Make a loop on one end by twisting the wire around one prong of the needle-nose pliers.

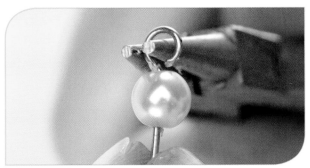

3 Bring the bead up next to the loop to check the size. Try to make the loop smaller than the bead.

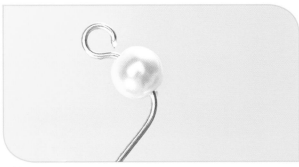

4 Bend the wire with the bead in the center.

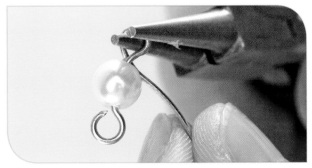

5 Make another loop.

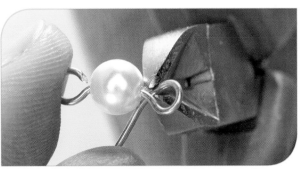

6 Use wire cutters to cut the excess wire.

## Making Necklaces

A wide variety of necklace chains, both finished and unfinished, can be purchased. For unfinished chains you will need to purchase small jump rings and clasps for the ends. A pair of pliers and wire cutters may also be required for putting together an unfinished chain. All the projects in this book can be made into charms or pendants simply by adding eye pins and jump rings.

## Making Bracelets

Bracelet chains can be used with charms to make dangly charm bracelets. Many supplies are available in local craft stores, so mix and match the different parts. Stretchy bracelets can be made using elastic and beads. To make a stretchy bracelet, follow the steps below.

1 Poke a hole through the center of the clay pieces prior to baking.

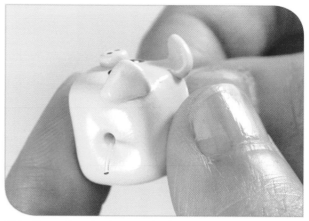

2 Once the clay has cooled, thread the elastic through your clay bead.

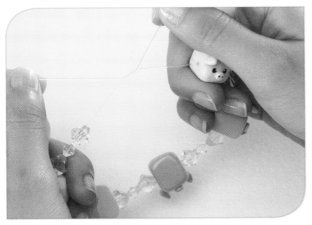

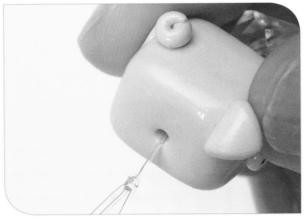

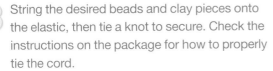 String the desired beads and clay pieces onto the elastic, then tie a knot to secure. Check the instructions on the package for how to properly tie the cord.

Add a dab of glue to the knot and pull it into the bead hole.

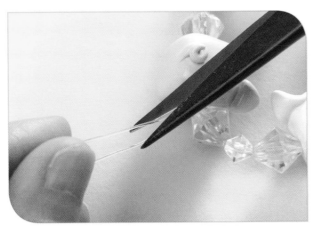

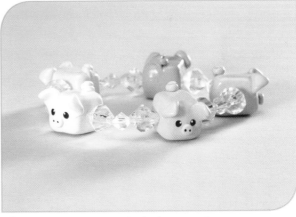

Snip off any extra cord.

Allow the glue to dry before wearing.

## Making Hair Clips and Rings

You can also make unique hair clips and rings with pieces that have flat bottoms. The process is the same for both.

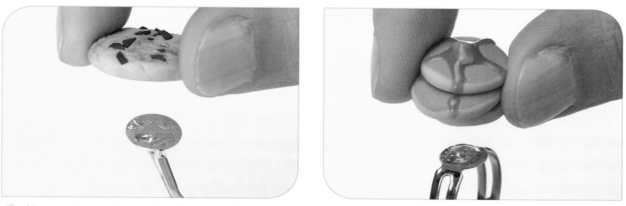

1. Use sandpaper to rough up the side of the clay piece that will be attached to the jewelry pad. Apply a strong glue to the surface of the pad.

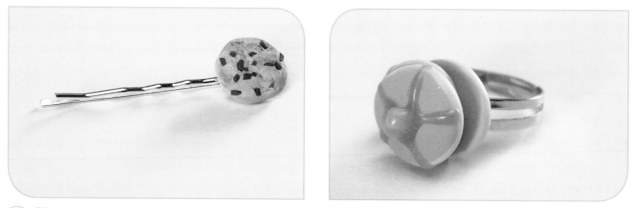

2. Place the polymer clay piece into the glue and make sure it's centered. Allow the glue to set for at least twenty-four hours or for the time specified on the glue bottle. Try to keep the entire piece on a flat surface so the bottom of the piece is parallel to the ground. Use a piece of clay or folded paper to hold the piece steady.

## Making Ear Wire Earrings

At the craft store, you will find a variety of ear wires that are suitable for small clay projects. You don't want the pieces to be too large, or they will be a heavy burden on the ears. Ear wires come in a variety of metals, including gold plated, sterling silver and surgical steel.

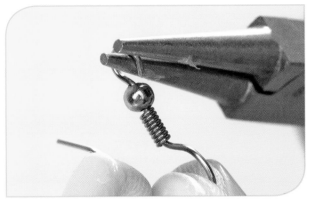

1 To assemble your earrings, find the opening of the ear wire and use your pliers to twist the wires apart, making a small gap.

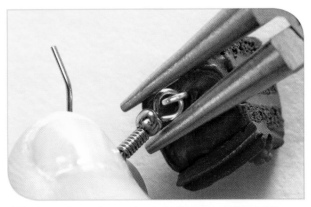

2 Slide your charm through the gap and twist the wires to close it up again. Twist the loop around if the charm isn't facing the right direction.

## Making Post Earrings

Earring posts can be attached by baking the post into the clay or by gluing the post to a baked piece of clay. When baking the post into the clay, place the post on the back of the clay piece and wrap some excess clay around the post of the earring to secure it. To glue the post to the clay, follow the steps for making hair clips and rings on preceding page.

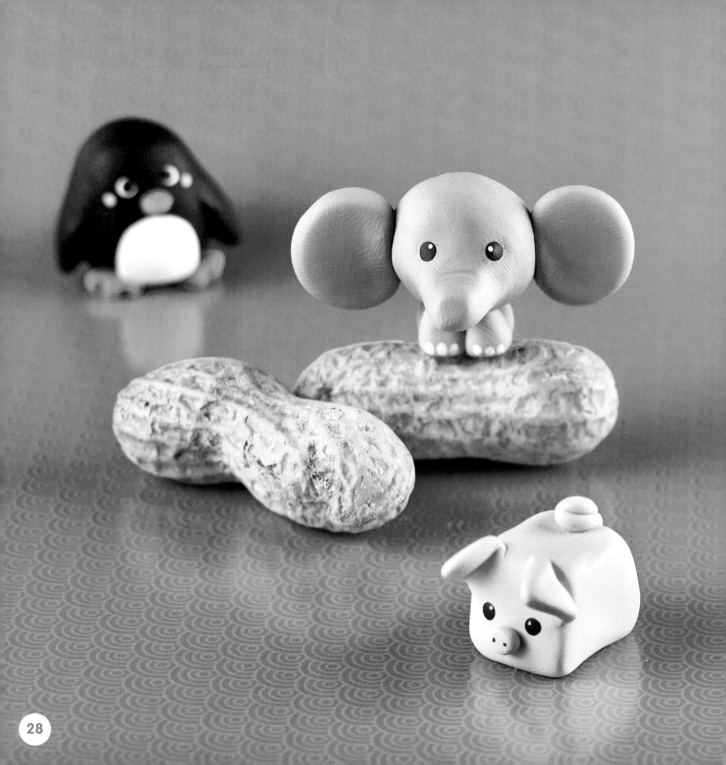

# animal designs

There are so many adorable animals in the world that it's hard *not* to be inspired! From fluffy land animals to squirmy ocean creatures, cute animals fill up this chapter. Start with a simple bunny and finish with a beautiful unicorn!

# bunny

This bunny is a perfect starting point for beginners. It's both simple and cute.

.: what you will need :.

Brown clay

White clay

Toothpick

Piercing tool or straight pin

18- or 20-gauge wire

Wire cutters

Ceramic tile or other work surface

Glaze and paintbrush, optional

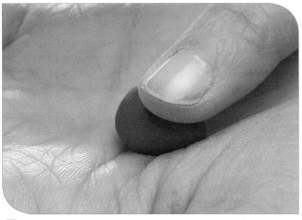

1 Start with a ball of brown clay approximately ⅝" (1.6cm) in diameter.

2 Roll one side of the ball between your fingers until you have an egg shape.

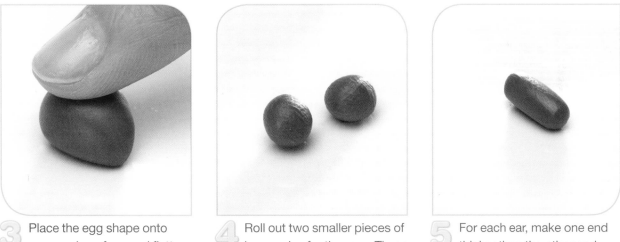

3 Place the egg shape onto your work surface and flatten one side down.

4 Roll out two smaller pieces of brown clay for the ears. These should be about one-fifth the size of the body.

5 For each ear, make one end thicker than the other and flatten the thinner end.

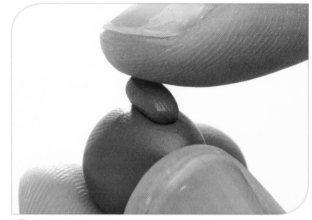

 Attach the first ear to the body.

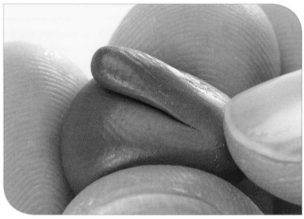

7 Smooth down the flat sides until the ear is blended with the body.

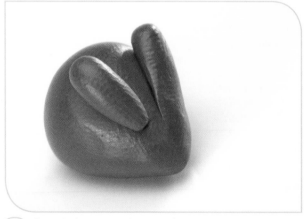

8 Attach the second ear and repeat the smoothing process.

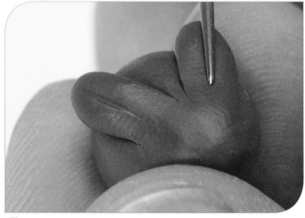

9 Use your piercing tool or a straight pin to press indentions into the ears.

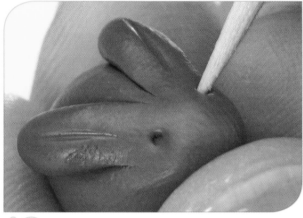

 Use a toothpick to make holes for the eyes.

11 For the tail, roll out a small ball of white clay about the same size as the ears.

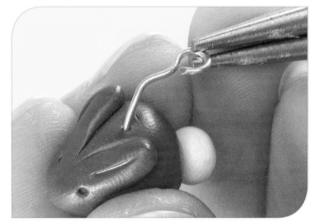

12 Press the tail onto the body.

13 To turn your piece into a charm, bend and insert an eye pin that's cut to a length slightly shorter than the length of the bunny. Bake your piece at the appropriate temperature and glaze when cool, if desired.

# pig

Square pigs? Sure, why not? Turning animals into different shapes can be fun, and this pig is just that!

.: what you will need :.

Pink clay (or mix red and white clay)

Black acrylic paint

White acrylic paint

Toothpick

Ceramic tile or other work surface

Piercing tool, optional

Glaze and paintbrush, optional

1 Shape the pink clay into a rectangle about ¾"× ½" (2cm × 1.3cm). Round the edges and corners of the rectangle by lightly smoothing them with your fingers. This will be the body of the pig.

2 Make two small pink triangles for the ears.

3 Attach the ears by putting the straight edge of one triangle on the corner of your pig's head.

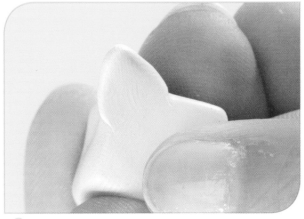

4 Use your finger to smooth out the clay where the ears attach to the body until blended.

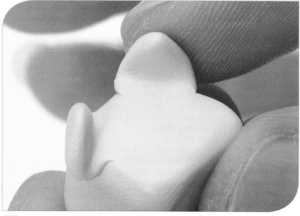

5 Fold down the triangle to make the ear floppy. Repeat with the other ear.

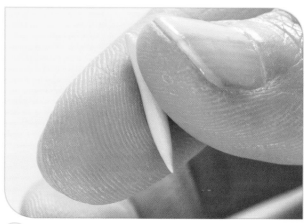

6 Roll out a snake about ¾" (2cm) long for the tail.

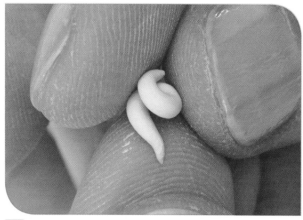

7 Curl up the snake, leaving a bit of the end uncurled to attach to the body.

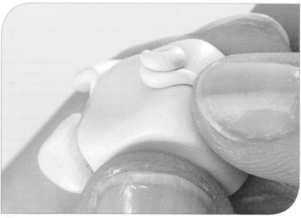

8 Place the tail on the body and smooth the extra clay into the back of the body.

**9** Make a small ball of pink clay for the nose.

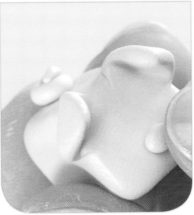

**10** Place the ball in the center of the face and squish the ball down.

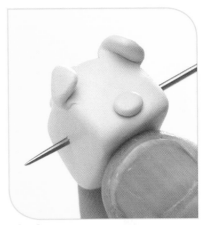

**11** If desired, turn your pig into a bead by poking a hole through the side. Bake your piece at the temperature recommended for the clay.

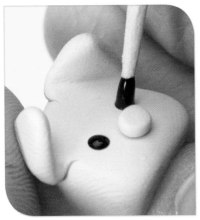

**12** After the clay has cooled completely, paint on the eyes using a toothpick and black paint.

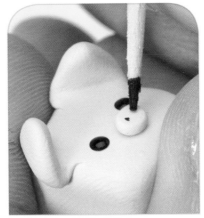

**13** With less paint on your toothpick, paint two small black dots on the nose.

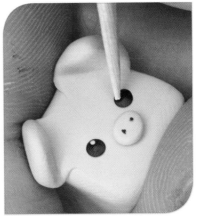

**14** To bring your pig to life, add a little dot of white paint to each eye with a toothpick. Once the paint is dry, finish with a glaze, if desired.

# elephant

Two things stand out about elephants: their big trunks and floppy ears. This elephant design focuses on both of these features.

.: what you will need :.

Gray clay (or mix white and black clay)

Black acrylic paint

White acrylic paint

18- or 20-gauge wire

Wire cutters

Piercing tool or straight pin

Toothpick

Ceramic tile or other work surface

Glaze and paintbrush, optional

1 Make a ball approximately 1" (2.5cm) in diameter with the gray clay.

2 To make the elephant's trunk, roll one side of the ball between your fingers until the ball turns into a teardrop shape.

3 Curve the trunk slightly upward and flatten the tip.

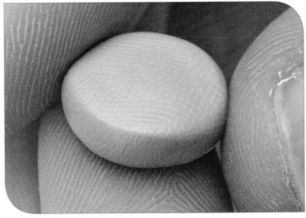

4 Make two more gray balls smaller than the body and squish them down into disk shapes. These will be the ears.

5 Cut two short pieces of wire roughly the length of the ear and stick them halfway into the sides of the body where the ears will go.

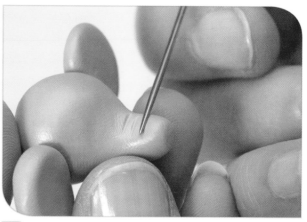

6 Thread one ear onto the wire and press the ear against the body until it sticks. Do the same on the other side with the second ear. You can give the ears dimension by curving them inward.

7 Using the side of the piercing tool, make three or four parallel lines on the trunk.

8 For the elephant's tail, roll a small tapered snake and flatten the thick side.

9 Place the snake on the back of the body with the flat part facing upward. Smooth the clay where the tail meets the body.

10 Roll four balls of clay, each a little less than half the size of the balls rolled for the ears.

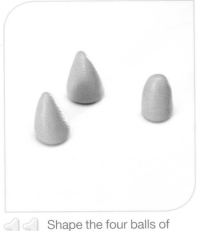

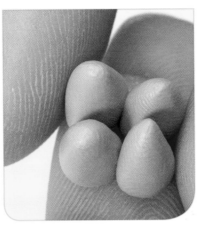

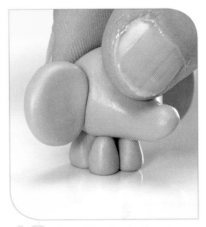

11 Shape the four balls of clay into short cylinders, tapering one end of each. These will be the legs.

12 Arrange the four legs into a square formation.

13 Press the body down onto the cylinders until they are well attached. Bake your piece.

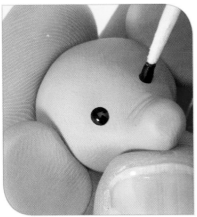

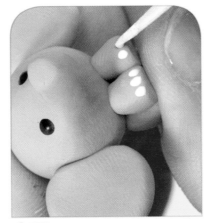

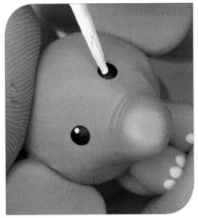

14 Once the clay has cooled, use the black paint and a toothpick to make two dots for eyes on either side of the trunk.

15 With white paint and a toothpick, paint three white dots on the front of the two front legs.

16 With the same paint and toothpick, paint small dots on the eyes. Allow the paint to dry and finish with a glaze, if desired.

# owl

In this project, you will add more details with paint. The basic shape is made with clay, but it is the paint that really brings the owl to life. Hoot!

.: what you will need :.

Brown clay

Tan clay

White acrylic paint

Black acrylic paint

Yellow acrylic paint

Brown acrylic paint

Piercing tool or straight pin

Toothpicks

Ceramic tile or other work surface

Glaze and paintbrush, optional

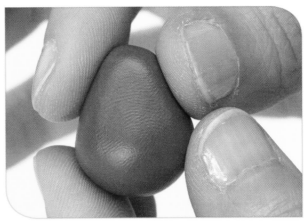

1 Roll a ball of brown clay approximately ¾" (2cm) in diameter.

2 Form the ball into a pear shape by pinching one side up.

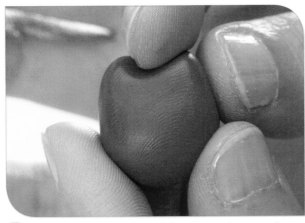

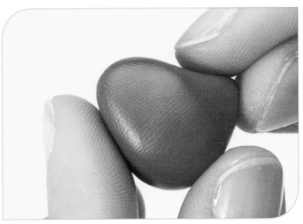

3 Press the narrow part of the shape down and create two points on the side for the ears.

4 Choose which side will be the back of the owl and pull out a little clay to create a tail. Try to keep the tail centered and pinch it out to a point.

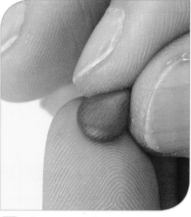

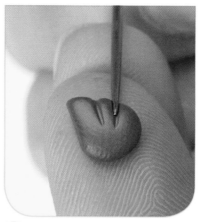

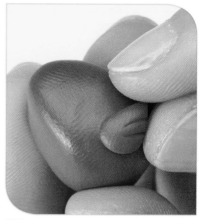

5 Create two flat teardrop shapes for the wings from brown clay.

6 Press the piercing tool on each wing to make one or two lines.

7 Press the wings to either side of the body.

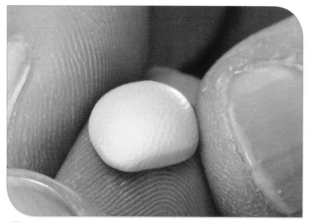

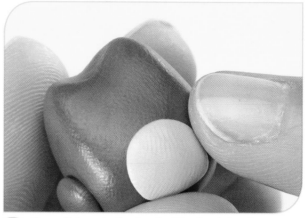

8 Roll out a small sheet of tan clay in an oval shape about one-third the size of the body.

9 Press this onto the front of the body for the stomach and bake your piece.

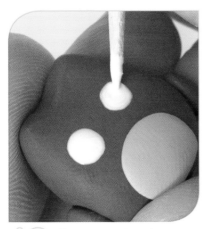

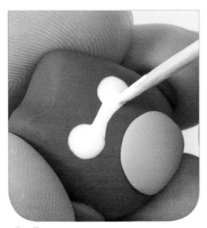

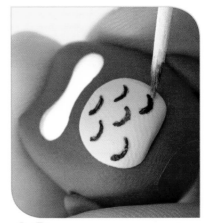

10 Once your piece has cooled, paint two white circles for the eyes using a toothpick.

11 Connect the circles in the middle to create a filled-in figure eight.

12 Draw little *U* shapes on the stomach with brown paint and a toothpick.

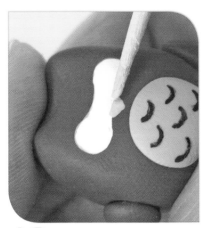

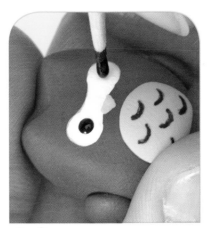

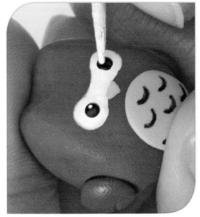

13 Paint a yellow triangle for the beak using a toothpick.

14 Paint black dots on the eyes with a toothpick.

15 Add a white dot of paint to the upper right of each eye. Once the paint has dried, glaze, if desired.

# penguin

Penguins are such playful little animals, and I tried to capture that in this design. This project would also look great in blue or pink.

.: what you will need :.

Black clay

White clay

Orange clay

Black acrylic paint

White acrylic paint

Pink acrylic paint

Toothpicks

Ceramic tile or other work surface

Glaze and paintbrush, optional

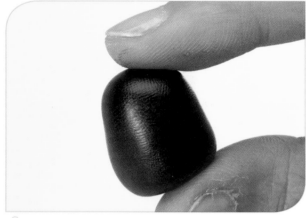

1 Roll a ball of black clay 1" (2.5cm) in diameter and flatten one side down on your work surface. Pull the rounded part upward a bit to make the top more oval shaped.

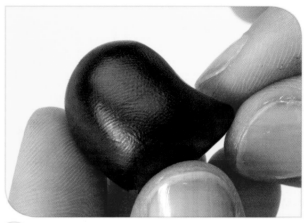

2 Pinch out a point on one side of the flattened bottom to make the tail.

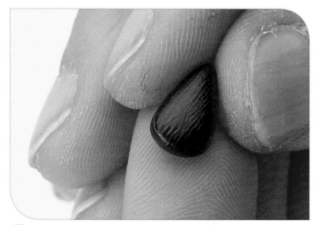

3 Using two equal amounts of black clay, create two long and flat triangle shapes about half the length of the body for the wings.

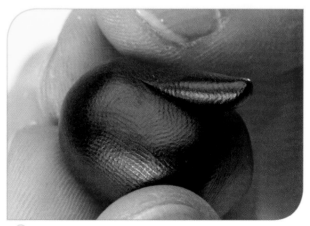

4 Attach the wings to the sides of the body and smooth down the clay with your finger.

5 Clean your hands so the black clay doesn't mix with the other colors. Make a flat circle of white clay that's about half as tall as the body.

6 Press the clay on the bottom front of the body, leaving enough room at the top for the face.

7 For the feet, make two small flattened circles with orange clay.

8 Using a toothpick or your fingernail, push each ball to form three webbed toes.

9 Place the feet facing slightly outward on the bottom of the body. Press gently to secure.

**10** Form a small piece of orange clay into a little beak.

**11** Attach the beak to the middle of the face above the white stomach. Bake your piece.

**12** Once the clay has cooled, paint white circles for the eyes using a toothpick.

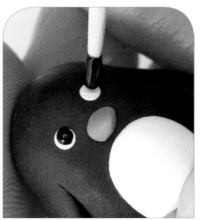

**13** Paint smaller black circles over the white circles, again using a toothpick.

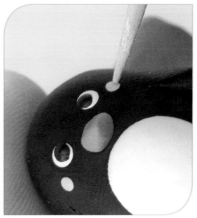

**14** Paint pink circles on the cheeks using a toothpick. Once the paint has dried, glaze, if desired.

# chicken

I created this chicken design after I attended a chicken festival! I saw all kinds of cool and crazy-looking chickens there, but for this project let's stick with a simple white hen.

.: what you will need :.

White clay

Red clay

Yellow clay

Black acrylic paint

White acrylic paint

Piercing tool or straight pin

Toothpicks

Ceramic tile or other work surface

Glaze and paintbrush, optional

Flat tool, optional

50

1 Make your white clay into an egg shape about 1" (2.5cm) long by rolling one end of a ball between two fingers.

2 Pinch the smaller end into a point to make the tail. Squeeze the head side down a little toward the tail to make the body thicker and the head slightly smaller.

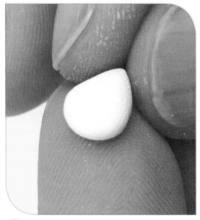

3 Take two small pieces of white clay and form teardrop shapes for the wings.

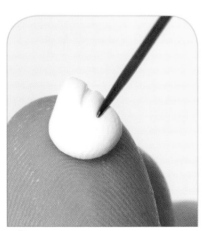

4 Use the piercing tool to make two lines on each wing.

5 Press the wings onto the sides of the body.

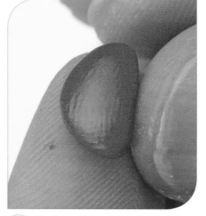

6 Make a long flat oval with red clay to start the comb.

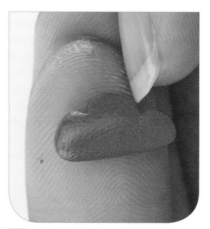

7 Using your fingernail or a flat tool, make two or three dips into one long side of the oval.

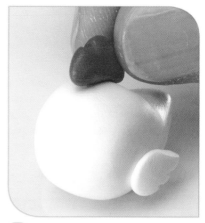

8 Press this piece down onto the top of the head with the dips standing up.

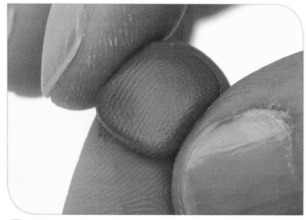

9 Make a flat square from a small piece of red clay. This is the start of the chicken's face.

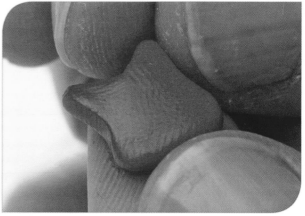

10 Using either your fingernail or a flat tool, push the clay to make small *V* shapes in the middle of each side of the square.

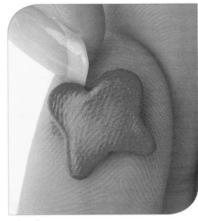

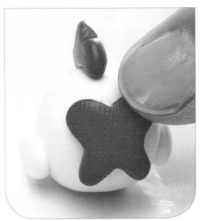

11 Pull down on two adjacent corners to form the wattle (the bottom hanging part of the face), then round out the other two corners.

12 Press this piece onto the body with the two longer corners facing down.

13 Shape a small piece of yellow clay into a tiny cone for the beak.

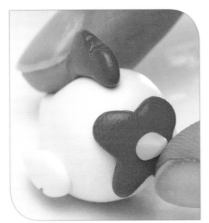

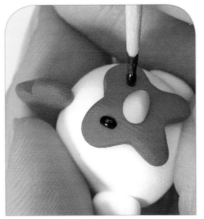

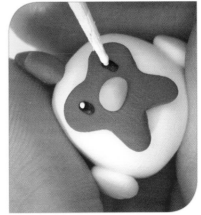

14 Press the beak onto the center of the face. Bake your piece at the appropriate temperature.

15 Once the clay has cooled, paint on the eyes with black paint and a toothpick.

16 Add white dots onto the eyes with a toothpick and white paint. Once the paint has dried, finish with glaze, if desired.

# cat

The base body shape of this cat can be used
to create many other four-legged animals.

.: what you will need :.

Black clay

Green acrylic paint

White acrylic paint

Pink acrylic paint

Toothpicks

18- or 20-gauge wire

Wire cutters

Ceramic tile or other work surface

Glaze and paintbrush, optional

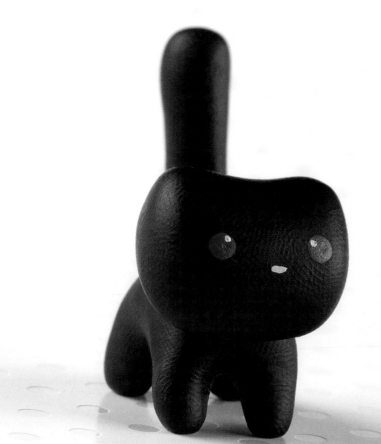

1 Condition a ball of black clay about 1" (2.5cm) in diameter. Squeeze the ball down into a thick square about half the original size.

2 Bend the square into an arch.

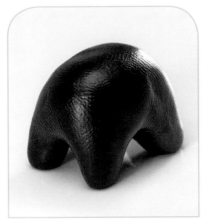

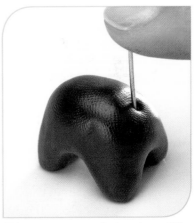

3 Pinch out each side of the arch into two sections and bend all four down in the same direction.

4 Stand the body up to ensure all four legs are even. Make any adjustments before baking so your cat will not be lopsided.

5 Cut a piece of wire about ¾" (2cm) long and stick it vertically into the body where the tail will be.

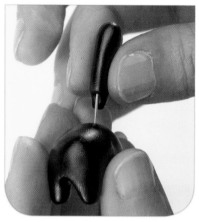

6 Roll a tapered snake of clay slightly longer than the wire. Round out the tip of one end. Leave the other end as is.

7 Skewer the tail onto the wire with the rounded end away from the body.

8 Smooth out the clay in the area where the tail connects with the body.

9 Roll out another ball of black clay, this one a bit smaller than the body. Shape the ball into a rounded rectangle.

10 Press down on one long side to create the ears.

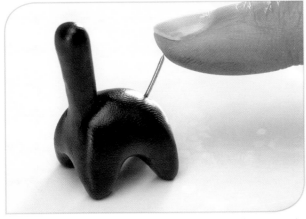

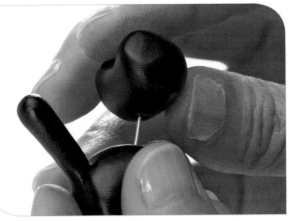

11  Cut a piece of wire about ½" (1.3cm) long and stick it into the body at a slight angle.

12  Thread the head onto this wire and press firmly so it stays on the body. Bake your piece at the appropriate temperature.

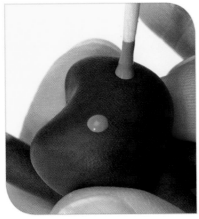

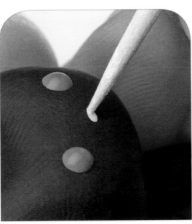

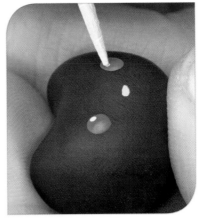

13  Once the clay has cooled, paint on the eyes with green paint and a toothpick.

14  With pink paint and a toothpick, paint a small oval for the nose.

15  Add tiny white dots on the eyes with white paint. Once the paint has dried, finish with glaze, if desired.

# dachshund

So many different dog breeds grace the planet that it was difficult to pick just one to demonstrate! Dachshunds are quite distinctive with their long bodies and short legs, and this design takes advantage of those unique features.

.: what you will need :.

Brown clay

Black clay

Black acrylic paint

White acrylic paint

Toothpicks

Ceramic tile or other work surface

Glaze and paintbrush, optional

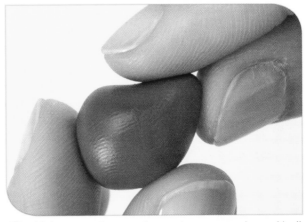

1. Roll out a thick log of brown clay about 1½" (3.8cm) long for the trunk of the body, making one side slightly thicker. The thicker side will be the front end of your dachshund.

2. Using more brown clay, make an egg-shaped ball a little less than half the length of the body. Pinch out the smaller end of the egg and tilt it slightly upward to create the snout.

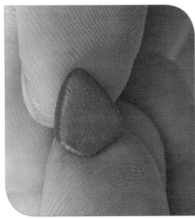

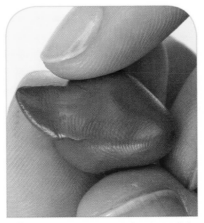

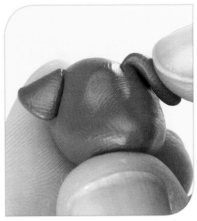

3. Make two small flat triangles for the ears from the brown clay.

4. Place the ears at the top of the head with one flat side of the triangle against the head and a tip pointing upward. Smooth out the clay where the ears and head connect.

5. Fold the ears downward until the points touch the head.

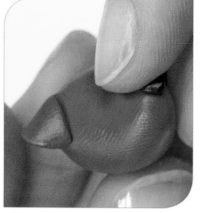

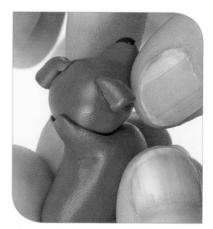

6 Make a small triangle from black clay and place it at the tip of the snout to create the nose.

7 Create a little dip or bowl on the front of the body by pinching the top and pulling up.

8 Place the head in this dip and smooth out the seam between the two parts to form one whole piece.

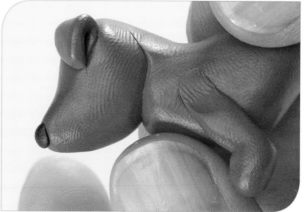

9 The dachshund's legs are short. To make a leg, roll out a short snake of clay and bend one end, pushing it in a little to make the paw thicker.

10 Attach the leg to the side of the body and smooth out the clay where the two parts meet. Make three more legs and attach them to the body in the same way. Balance the body on all four legs to make sure the legs are even and the bottoms of the feet are flat.

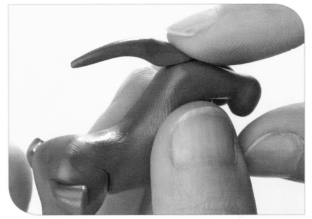

**11** For the tail, roll out a thin tapered snake from brown clay.

**12** Attach the tail to the back side of the body. Smooth out the clay where the tail meets the body. Bake your piece at the appropriate temperature and let it cool.

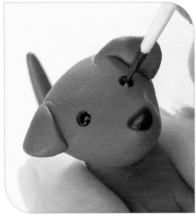

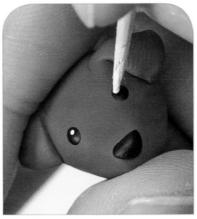

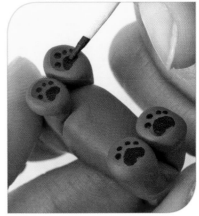

**13** Using black paint and a toothpick, paint small circles for the eyes.

**14** Add little dots of white paint to the eyes once the black paint has dried.

**15** Use black paint and a toothpick to paint paw prints on the bottoms of the feet. Feel free to make additional spots or markings on your dog. Finish with a glaze, if desired.

# octopus

Since the first time I saw an octopus display at the American Museum of Natural History in New York City, I've been obsessed. Something about them captured my imagination, and I just had to make a cute version.

.: what you will need :.

Orange clay

Red-orange acrylic paint

Black acrylic paint

White acrylic paint

Pink acrylic paint

Toothpicks

Ceramic tile or other work surface

Glaze and paintbrush, optional

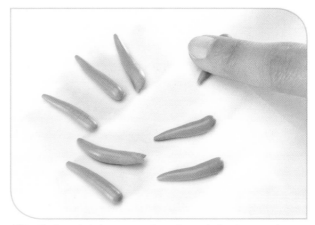

1 For the body, roll a ball of orange clay about ⅞" (2.2cm) in diameter.

2 Roll out eight tapered snakes of clay in equal length for the tentacles. Try to make the length of each equal to one-and-a-half times the body diameter, or 1⅓" (3.4cm).

3 Flatten the wide end of the tapered snake and place the flattened end on the bottom of the body. Bring the tentacle up and curve the end.

.: **measuring clay** :.
When measuring out equal amounts of clay, try rolling them into balls or little cubes so you can eyeball the sizes. You can also roll out a snake and slice it into the number of pieces you need.

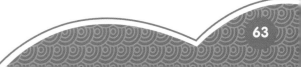

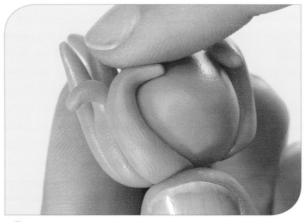

4 Arrange the rest of the tentacles around the body, bending them in different directions to indicate motion. Keep an area free of tentacles for the face.

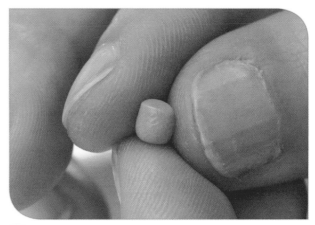

5 Make a much smaller ball of orange clay and flatten the ends to make a cylinder.

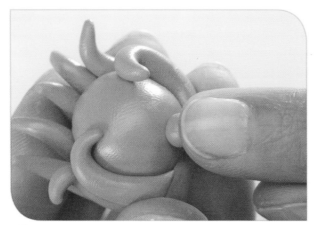

6 Press the cylinder onto the body for the mouth and flatten the cylinder a bit more.

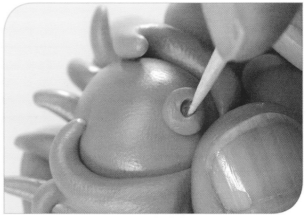

7 Using a toothpick, hollow out a small, shallow hole in the cylinder to make an open mouth. Bake your piece and let it cool.

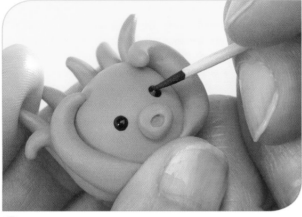

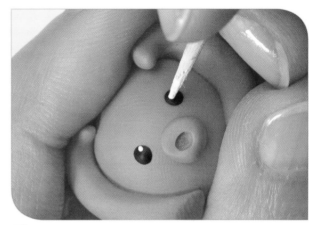

8 With black paint and a toothpick, paint black circles for the eyes.

9 Once the paint is dry, add highlights to the eyes with white paint and a toothpick.

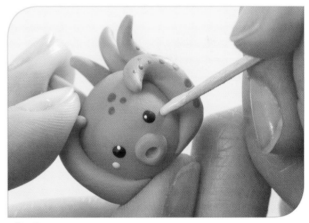

10 With red-orange paint and a toothpick, paint small dots on each tentacle, making the dots smaller as you reach the tip.

11 Add three red-orange dots of paint to the forehead of the octopus, too. Paint rosy cheeks on the octopus with pink paint and a toothpick. Once the paint is dry, finish with a glaze, if desired.

# whale

Here's another ocean creature that holds a special place in my imagination. The water spout on this whale project is really fun to make!

**.: what you will need :.**

Light blue clay

Blue clay

Black acrylic paint

White acrylic paint

Pink acrylic paint

Toothpicks

Ceramic tile or other work surface

Glaze and paintbrush, optional

1 Make a rounded teardrop shape about 1¼" (3.2cm) long out of light blue clay.

2 Flatten the tip slightly. Bend the tip to one side, then pinch out some clay on the other side to mirror the bend.

3 Slightly tilt the entire tip upward to make the tail.

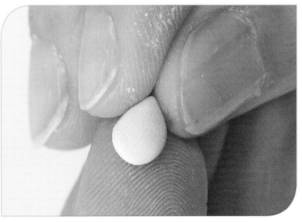

4 Using light blue clay, make two small flat teardrop shapes.

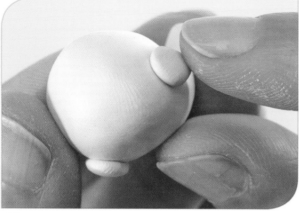

5 Press these onto the sides of the body for the flippers.

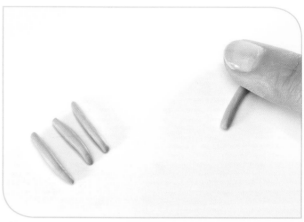

6 For the spout, use blue clay to make four small snakes about ¾" (1.9cm) long.

7 Curl one end of each snake and leave the other end straight.

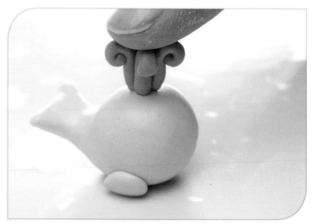

8 Arrange the snakes together with the curled parts pointing out, and place them at the top of head. Press down gently to secure. Bake your piece at the appropriate temperature and let cool.

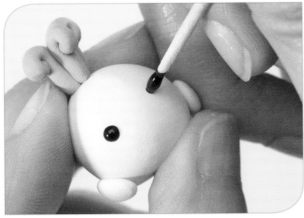

9 With black paint and a toothpick, paint black circles for the eyes.

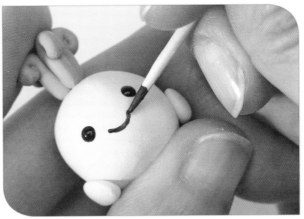

10 Use the same paint to add a smiling mouth to your whale.

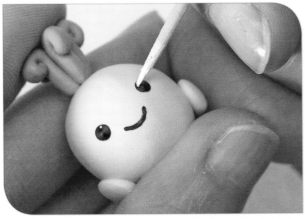

11 Once the black paint has dried, add highlights to the eyes with white paint and a toothpick.

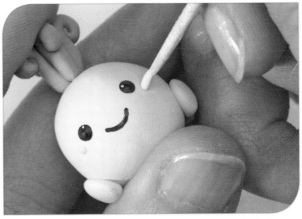

12 With pink paint and a toothpick, add circles on each cheek. Once the paint has dried, finish with glaze, if desired.

# unicorn

You've reached my favorite design of all! Unicorns may not exist, but that makes them even more fun to make. Let your imagination run free with this design; try out different color combinations and hair shapes.

.: what you will need :.

White clay

Gold or silver clay

Gold or silver acrylic paint

Black acrylic paint

White acrylic paint

Pink chalk pastel

Toothpicks

Blade

18- or 20-gauge wire

Wire cutters

Soft paintbrush for dusting

Paintbrush for painting

Ceramic tile or other work surface

Plastic or glass container

Glaze and paintbrush, optional

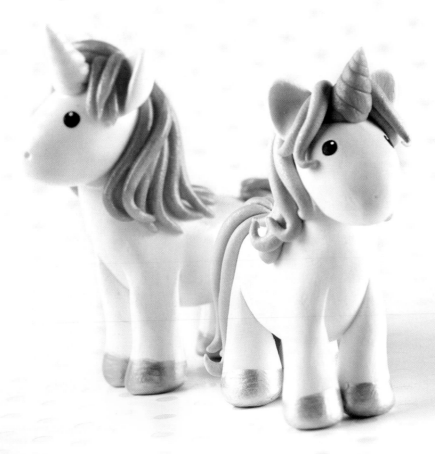

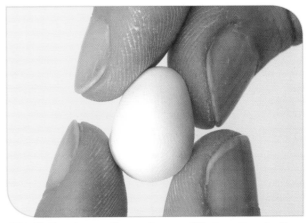

1 Start with a ball of white clay about 1¼" (3.2cm) in diameter and roll it into a long egg shape. Pull the thinner side out and curve it up to make the neck. Flatten out the end and make a dip where you can rest the head.

2 Roll out a small egg shape a little less than half the size of the body for the head.

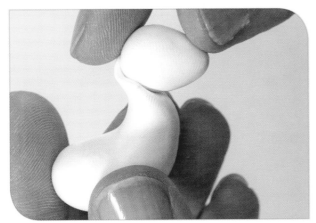

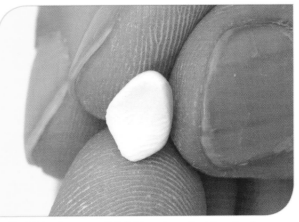

3 Place the head on top of the neck. Smooth the sides of the neck up onto the head so that the clay blends together.

4 Make two small flat triangles of white clay for the ears.

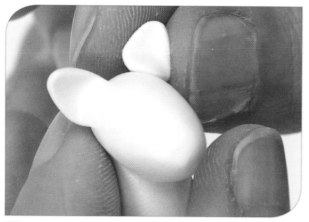

5 Place the ears at the top of the head. Smooth and blend the clay where the ears meet the head.

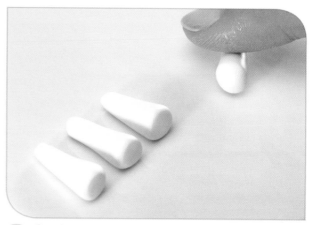

6 Continuing with white clay, make four cylinder shapes for the legs; make two of these legs slightly thinner for the front legs. On each leg, slightly pinch the top to make it flat.

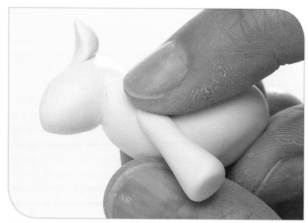

7 Place the flat end of the leg onto the body and smooth the clay to blend. Repeat for the three other legs.

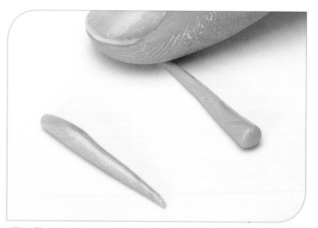

8 To make the horn, take two equal amounts of gold clay and roll them into thin tapered snakes.

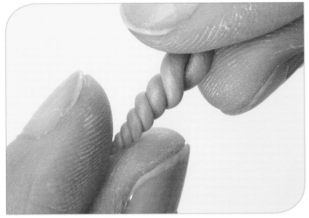

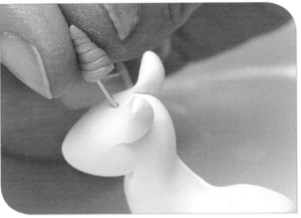

**9** Starting with the two thinner ends, twist the two pieces together until they form a horn shape. If the horn is too long, slice off the thicker end to the right length.

**10** Cut a piece of wire ½" (1.3cm) long and insert it into the center of the head. Place the horn onto the wire and press down to secure.

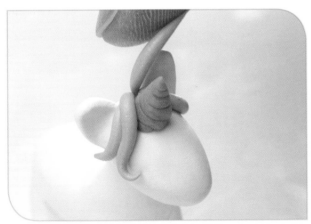

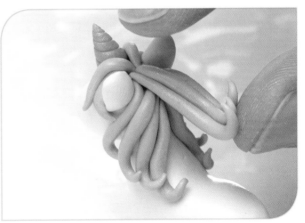

**11** Making the hair is the fun part. Take your gold or silver clay and start rolling out thin snakes of various lengths tapered on both ends. Put some shorter pieces on the top of the head near the horn.

**12** Place longer tapered snakes trailing down the back of the neck and tail. Start with the bottom layers at the crown of the head and work your way around. The strands of hair should stick together as you work, but press down lightly if they feel loose.

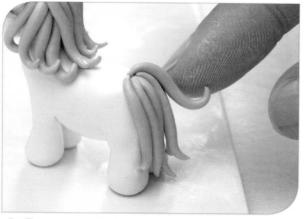

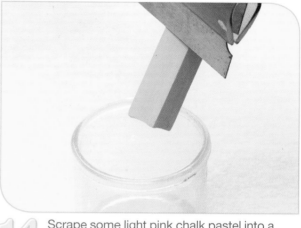

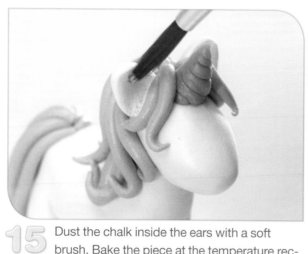

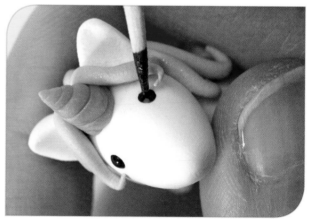

13 Arrange the hair any way you want and play around with different curves or make curls by twisting the clay. Add long snakes to the tail, too.

14 Scrape some light pink chalk pastel into a container with your blade tool.

15 Dust the chalk inside the ears with a soft brush. Bake the piece at the temperature recommended on the clay package and let it cool.

16 With black paint and a toothpick, paint black circles for the eyes.

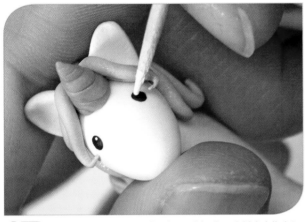

**17** Once the black paint has dried, add highlights to the eyes with white paint and a toothpick.

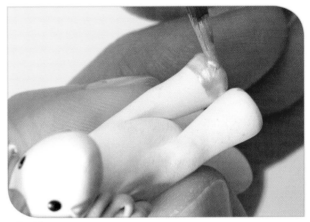

**18** Using either gold or silver paint, paint hooves on the bottom of each leg. Paint approximately the same distance up each leg.

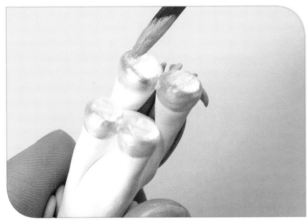

**19** Paint the bottoms of the hooves as well. Once the paint has dried, finish with glaze, if desired.

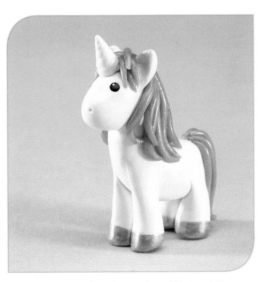

This unicorn is made with straight gold hair, gold hooves and a white horn.

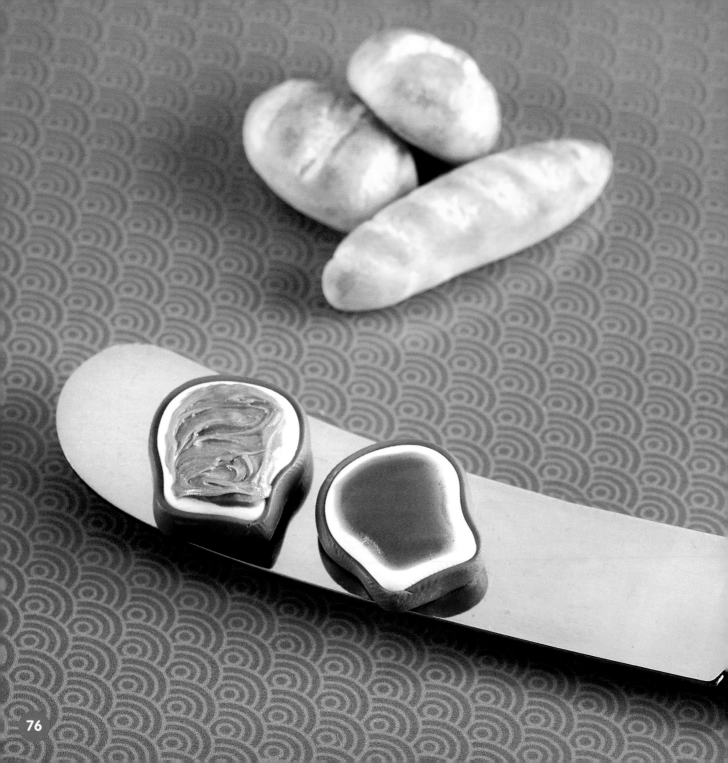

# food designs

Oftentimes the steps to creating realistic-looking minia-
ture food follow closely the steps to assembling real food.
First make the cake, then add frosting, and finish with a pretty
raspberry. Take a look at some cookbooks for inspiration!

# bread loaf

Bread comes in all different shapes, sizes and flavors! They're all delicious, so let's start by baking a simple loaf of bread.

.: what you will need :.

Translucent clay
White clay
Light yellow clay
Yellow chalk pastel
Red-brown chalk pastel
Cornstarch
Aluminum foil
Soft paintbrush
Blade
Ceramic tile or other work surface
Plastic or glass container
Glaze and paintbrush, optional

1 Create the bread dough by mixing together equal amounts of white and translucent clay with a pinch of yellow.

2 Shape your dough into an oval loaf of bread about 1" (2.5cm) long. Lightly press down on your loaf to make the bottom flat.

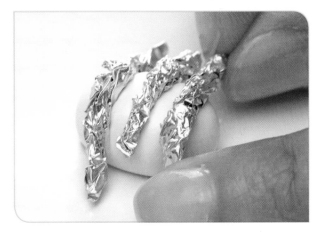

3 Crumple up three small pieces of aluminum foil into thin snakes, making each as wrinkly as possible. Press the crumpled foil snakes in a row on the top of the loaf.

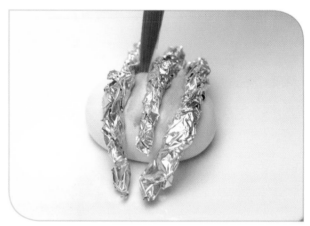

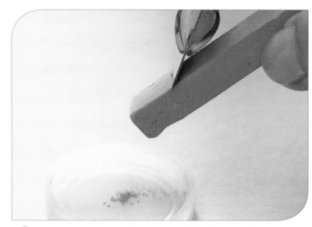

4 Prepare some yellow pastel chalk by using your blade tool to scrape the chalk into a small container or on a piece of paper.

5 Brush the yellow chalk all over the bread with a soft brush, but do not let the chalk get under the foil.

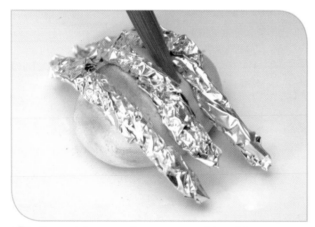

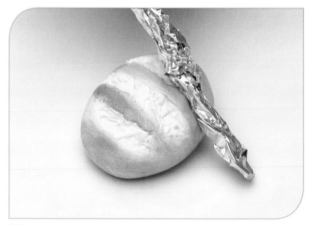

6 Repeat the scraping process with red-brown pastel chalk and brush it on the top and bottom of the loaf, again not letting it under the foil.

7 Finish by dusting a little bit of cornstarch on top (to look like flour) before baking, if desired. Remove the foil strips.

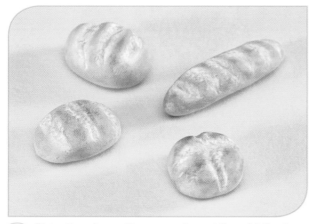

8 Bake the piece. Glaze your bread if you'd like it to shine, but for a more realistic bread, leave it unglazed. To make different types of bread, use the same technique but create different shapes. Shown here are examples of a loaf, a baguette and a boule.

### .: translucent clay :.

Translucent clay can result in some interesting effects. Different brands have varying degrees of translucency, so experiment to see which ones you like best. Adding translucent clay to your baked goods and food projects will make them look more realistic.

# doughnut

Sweet, delicious doughnuts! Doughnuts are another fun project that offers endless possibilities. Once you've mastered the basic shape, you can change it up as much as you want.

.: what you will need :.

Translucent clay

Beige or ecru clay

Dark brown clay

Red clay

Orange clay

Yellow clay

Green clay

Blue clay

Purple clay

White clay

Liquid polymer clay

Blade

Ceramic tile or other work surface

Glaze and paintbrush

1 Mix beige clay with translucent clay in a 1:1 ratio. Form this mixture into a disk about 1" (2.5cm) in diameter and ¼" (6mm) thick. Use the handle of a paintbrush, or any other stick, to poke a hole into the doughnut.

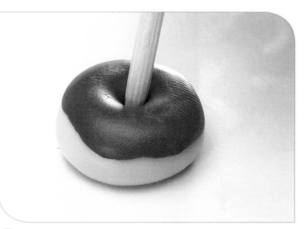

2 For the frosting, roll out a thin circle of dark brown clay slightly larger than the doughnut. Lay this on top and poke a hole through it. Press down into the hole to secure the frosting.

3 Roll out thin snakes of red, orange, yellow, green, blue, purple and white clay. Bake these for five minutes in the oven.

4 Once the clay has cooled, slice the snakes into short sprinkles.

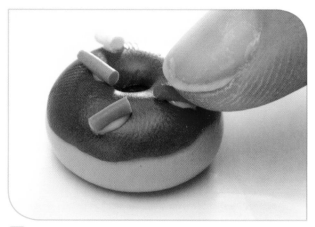

5 Put a drop of liquid clay onto the doughnut and place a sprinkle on top of it. Repeat for as many sprinkles as you'd like. The liquid clay will ensure a strong bond between the sprinkles and the frosting.

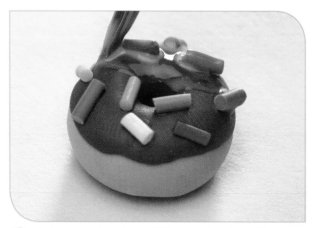

6 Bake your doughnut. When cool, finish with a glaze on top to make your frosting shiny.

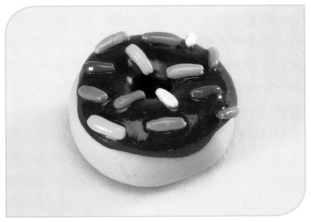

7 Add glaze to the sprinkles, too, if desired.

Here's a strawberry doughnut with a chocolate swirl.

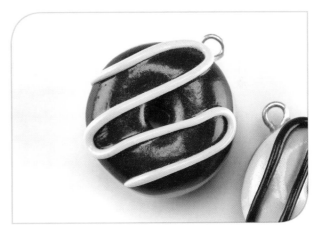

And a chocolate doughnut with a strawberry swirl!

# pancakes

In this project, you will use liquid clay to make some realistic-looking maple syrup. This technique is great for making translucent sauces, syrups and other liquids.

.: what you will need :.

Translucent clay

Beige or ecru clay

Red-brown clay

Light yellow clay

Liquid polymer clay

Red-brown chalk pastel

Mixing tool (flat tool preferred)

Plastic or glass container

Ceramic tile or other work surface

Glaze and paintbrush

1 Mix beige clay with translucent clay in a 1:1 ratio. Make two or three flat pancakes from this mixture.

2 Make a mixture of three parts beige and one part red-brown clay. With this clay, make a flat circle slightly smaller in diameter than the pancakes. Make one circle for each pancake.

3 Place the flat circles onto your pancakes.

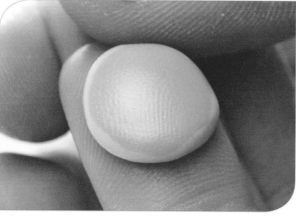

**4** Lightly smooth the edges to make the piece look like a browned pancake.

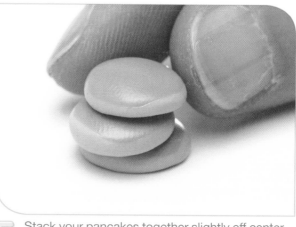

**5** Stack your pancakes together slightly off center.

**6** Mix the light yellow clay with translucent clay in a 1:1 ratio to make your butter. Create a small square and place it on top of the pancakes.

**7** Squeeze some liquid polymer clay into a container or plate. With your blade tool, scrape some red-brown chalk pastel into the liquid clay.

8  Mix the liquid clay and chalk until there are no lumps. Using your mixing tool (something flat is recommended), drizzle the mixture onto the pancakes. Allow some of the syrup to drip down the sides of the pancakes to make it look realistic.

9  Bake your piece. Once it has cooled, use a small paintbrush to paint glaze onto the syrup.

# cinnamon roll

Sweet, sweet cinnamon rolls! You can practically smell them just by looking at them. The frosting on top may be a bit challenging to make, but keep practicing and soon it will be perfect.

.: what you will need :.

Beige or ecru clay

Dark brown clay

Liquid polymer clay

White clay

Red-brown chalk pastel

Toothpick

Mixing tool (flat tool preferred)

Blade

Clay roller

Plastic or glass container

Ceramic tile or other work surface

Glaze and paintbrush

Jump ring, optional

Necklace chain, optional

18- or 20-gauge wire, optional

Wire cutters, optional

Roll a snake of beige clay roughly 2½" (6.4cm) long and ½" (1.3cm) wide.

Flatten the snake slightly with a clay roller.

Repeat steps 1 and 2 with the dark brown clay, but make this second snake slightly narrower and shorter. Lay the dark brown clay on top of the beige clay.

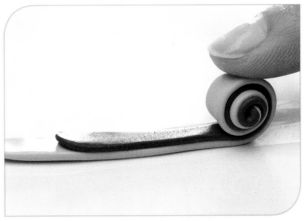

Start at one end and roll up the clay strips with the dark brown in the center.

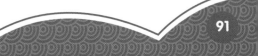

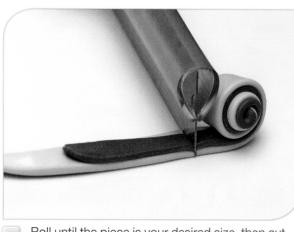

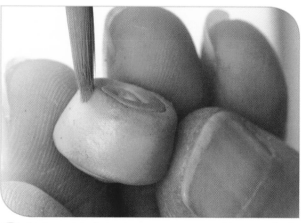

5 Roll until the piece is your desired size, then cut off any extra clay at the end.

6 Using a blade tool, scrape some red-brown chalk pastel into a container. Use a soft paintbrush to dust the bottom and top of the bun to make it look freshly baked.

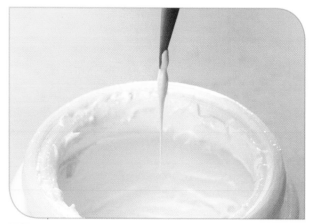

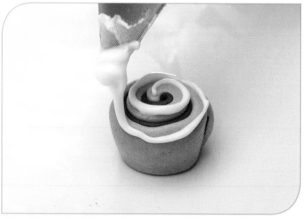

7 Create the frosting using liquid clay and a pinch of white clay to thicken it up. This mixture should be liquid enough that you can drizzle it, but thick enough that it won't run completely off the side of your roll.

8 To apply the frosting, use your mixing tool to drizzle the liquid clay mixture onto the beige half of the roll. Follow the line of the beige clay around the roll, starting from the center.

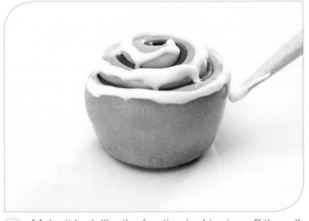

**9** Make it look like the frosting is dripping off the roll by maneuvering the frosting down with a toothpick.

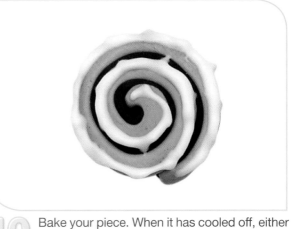

**10** Bake your piece. When it has cooled off, either glaze the frosting or leave it unglazed if it already has a slight shine. If there isn't enough color, dust some more pastel onto the roll.

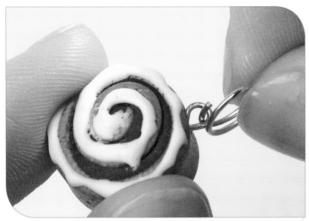

**11** The cinnamon roll would look great as a necklace pendant. Add an eye pin before baking, and once it is finished baking, attach a jump ring or split ring.

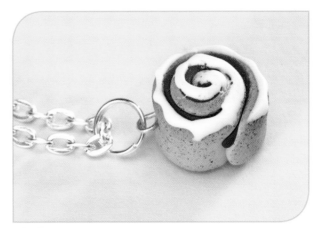

**12** Put the pendant on a necklace chain, and you've got yourself a tasty treat on the go!

# peanut butter & jelly sandwich

This project can be made in different sizes for pendants, earrings, rings or whatever you can dream up. It also uses two different liquid clay techniques, so you can easily compare the textures and finishes of both.

White clay

Red-brown clay

Liquid polymer clay

Purple chalk pastel

Clay roller

Mixing tool (flat is preferred)

Plastic or glass mixing containers

Blade

Ceramic tile or other work surface

Glaze and paintbrush

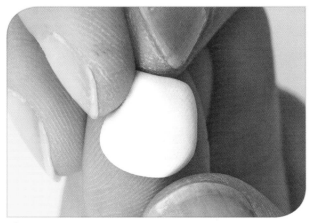

1 Shape a small piece of white clay into a flat square. Pinch in the sides of the square and round out the two corners that now stick out. Shape the top of the bread slice into a round half circle. Repeat the shaping process with another piece of white clay.

2 Roll out a long snake of red-brown clay about half the width of the slice of bread. Flatten the snake with the rolling tool. This will be the bread crust.

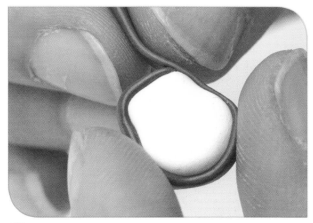

3 Starting at one corner, outline the bread with the crust. If you have excess brown clay, cut it off. Smooth down the spot where the two crust ends meet. Bake your bread slices for 5 minutes in the oven, just enough time to slightly harden the pieces.

### .: re-baking :.

Polymer clay can be re-baked as many times as needed. This comes in handy when making projects that have multiple components, such as cupcakes with sprinkles and cookies with chips. If you know you'll be baking a piece a second time, it's a good idea to initially bake it for a short amount of time, until it is just hardened (roughly 5–10 minutes, depending on size).

4 Make the grape jelly by mixing liquid clay with some purple pastel chalk. Use your blade tool to scrape the chalk into the liquid clay. Either mix until the two are completely combined, or leave some chunks to look like bits of fruit.

5 Make peanut butter by mixing liquid polymer clay with a tiny bit of red-brown clay. Mix until you get a thick paste that is spreadable but not runny. If it is runny, add more red-brown clay; if it is too thick, add more liquid polymer clay.

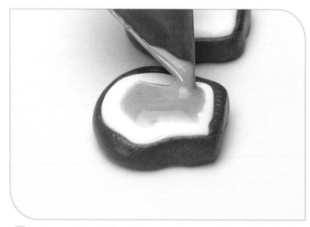

6 Spread the jelly mixture onto one slice of baked bread and set it aside on your baking sheet.

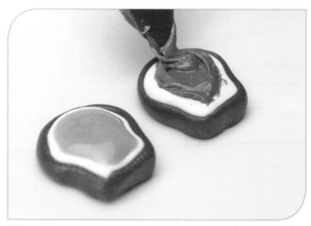

7 Spread the peanut butter onto the other slice of bread. Bake the pieces for 10 minutes.

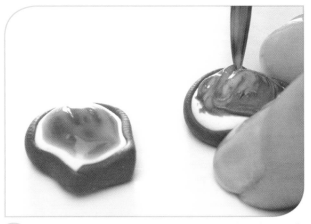

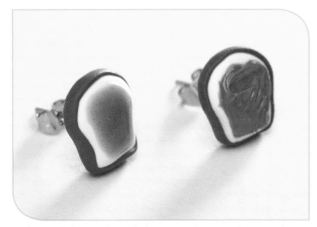

8 Once your pieces are done baking, add a layer of glaze to the peanut butter. The jelly should already have a nice glossy finish, but if you want it to be shinier, add glaze to it, too.

Make small slices and attach them to earring posts for cute mismatched jewelry. See page 27 of Jewelry-Making Techniques for details on making earrings.

### .: best friend gift idea :.
If you're looking for a fun gift to give your best friend, make the project as shown but add an eye pin to the top of each slice of bread. Place a necklace chain through each eye pin, then give one necklace to your friend and keep the other for yourself!

# strawberry ice cream cone

In this project, you will make an ice cream cone mold using scrap clay. This technique can be used to make all different kinds of texture molds. You can also make a mold from silicone, if you prefer.

.: what you will need :.

Light pink clay

Dark pink clay

Beige or ecru clay

Translucent clay

Scrap clay

Red-brown chalk pastel

Cornstarch

Aluminum foil

Parchment paper

Soft paintbrush

Clay roller

Straightedge

Blade

Ceramic tile or other work surface

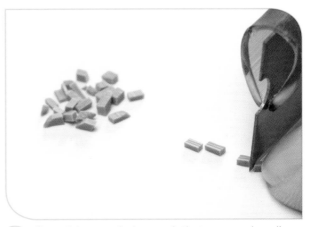

1 Roll the dark pink clay into a flat sheet about the size of your thumb. It doesn't need to have any specific shape. Place this into the oven for 5 minutes, or until it's hard.

2 Once it has cooled enough that you can handle it, slice off small chunks in all different sizes until the whole sheet is sliced up. These will be the strawberry chunks.

3 Knead the light pink clay until it's soft. Add in the strawberry chunks and mix until they're evenly distributed. As you work the clay, notice that when you fold the clay, it creates a crackly texture. If it doesn't, flatten the clay and place it between two pieces of plain white paper to leach out some of the plasticizer.

4 Round out the ice cream with the crackled texture on top to create a ball. Place the ball on your work surface and use a blade tool to scrape down the sides of the ball to add more texture.

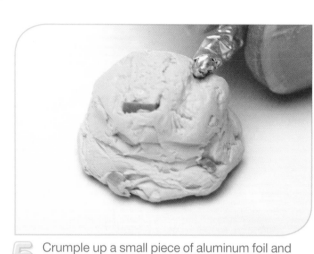

5 Crumple up a small piece of aluminum foil and press perpendicular lines along the cracks on top.

6 Flatten the scrap clay into a sheet to make a mold for the cone.

7 Use a flat item to impress parallel lines in the clay. I like to use a piece of cardstock, thin cardboard or thin plastic to make the lines.

8 Use the same flat item to impress lines in the opposite direction, thereby making a grid. Bake your mold for 5–10 minutes and let cool.

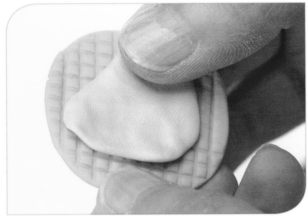

9 Mix beige or ecru clay with translucent clay in a 1:1 ratio. Dust the mold you made previously with some cornstarch and flatten the clay mixture into the mold in a rounded triangle shape.

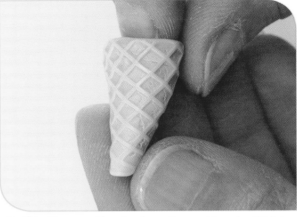

10 Remove the clay from the mold and roll it into a cone shape. If the cone seems too large for your ice cream, flatten the clay out again and cut off a bit from the sides.

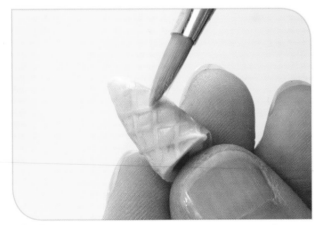

11 Use a blade tool to scrape off some red-brown pastel. Brush it onto the cone with a soft paintbrush. Try to keep the color on the ridges of the cone. This will make it look more realistic.

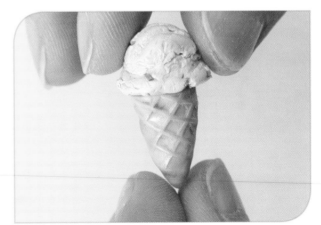

12 Place the ice cream onto the top of the cone and press down lightly to secure. Fold a piece of parchment paper accordion-style and place your ice cream cone in the folds to prop up while baking. Bake your piece, and glaze it when it's cool, if desired.

# cupcake

This cupcake project will, once again, challenge you to apply several different techniques to your work. Try making a bunch of cupcake bases and decorating them in all different "flavors"!

.: what you will need :.

Dark brown clay

Light pink clay

Light blue clay

Light purple clay

Liquid polymer clay

Piercing tool or straight pin

Stiff-bristled toothbrush

Mixing tool (flat preferred)

Clay roller

Plastic or glass container

Ceramic tile or other work surface

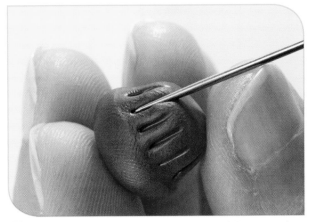

**1** Roll a short, thick log with the dark brown clay. Roll one end of the log on your work surface so that it tapers a little bit. To create the cupcake top, press the thick end down and round it out by rubbing with your fingers from the center to the sides.

**2** Make vertical lines along the base of the cupcake with your piercing tool or straight pin, spacing them as evenly as possible. These lines should look like the lines that a paper liner leaves on the cupcake.

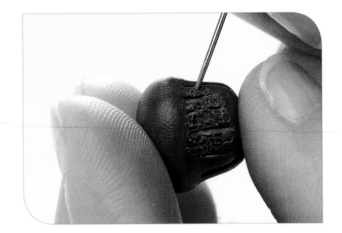

**3** If you'd like, add some texture to your cupcake base by stirring up the cake. Use the end of a piercing tool to make tiny circles in the clay. The more you stir, the more textured and cake-like the clay becomes.

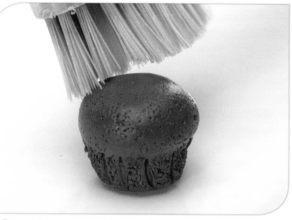

4 Add texture to the top of the cupcake by tapping a stiff-bristled toothbrush up and down gently.

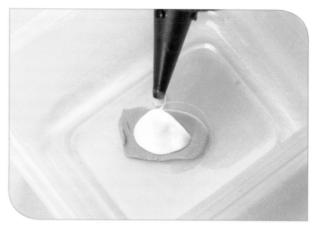

5 To make the frosting, place a bit of light pink clay in a container and mix it with a few drops of liquid clay until a thick paste forms.

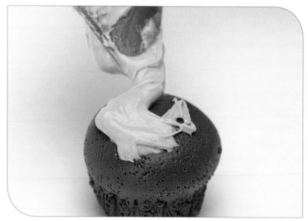

6 Spread the frosting on top of the cupcake, smoothing it in a circular motion. Work from the outside toward the center.

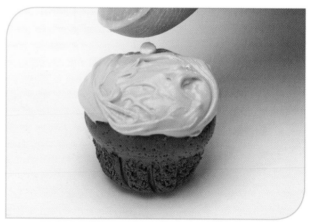

7 Make tiny balls with pink, blue and purple pastel clays. Flatten the balls into circular sprinkles and place these on top of the frosted cupcake.

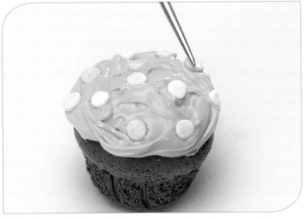

 Spread the sprinkles out randomly across the cupcake. Use a piercing tool to push them down into the frosting.

Bake your piece. When cool, glaze the frosting, if desired.

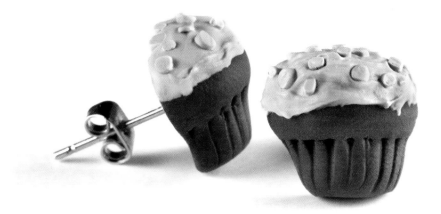

Easily create earrings by cutting a cupcake in half and attaching the flat sides to blank posts with a strong adhesive.

# chocolate chunk cookies

These chocolate chunk cookies make nice earrings, necklace pendants or miniatures for your dolls. Mix up some extra "dough" and save it in a container for any time you feel like baking up some cookies.

.: what you will need :.

Translucent clay

Beige or ecru clay

Dark brown clay

Red-brown chalk pastel

Aluminum foil

Stiff-bristled toothbrush

Clay roller

Soft paintbrush

Blade

Plastic or glass container

Ceramic tile or other work surface

1 To make the dough base for the cookies, mix some beige or ecru clay with translucent clay in a 1:1 ratio. Set this aside while you make your chocolate chunks.

2 Roll a thin sheet of dark brown clay; it can be any shape. Bake it for 5 minutes.

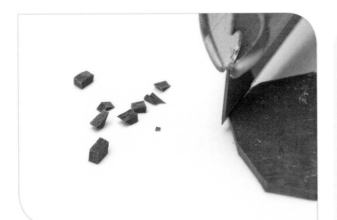

3 Once it has cooled, take your blade or knife and start slicing it into small pieces. The size of the chocolate chunks will vary depending on the size you plan to make your cookies. Put the chocolate chip pieces into a small bowl or container to keep them together.

### .: chocolate chips :.

To make the chocolate look more like chips rather than chunks, roll dark brown clay into a very thin snake, roughly the size of a toothpick. Bake for 5 minutes. When cool, slice the snake into small pieces.

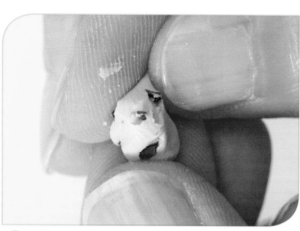

4 Mix the chocolate chunks into the dough you made in step 1 and knead until the chunks are evenly distributed.

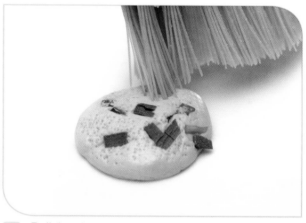

5 Roll the clay into a ball and then flatten it. Don't worry about making a perfect circle since real cookies are a bit lumpy. Grab a toothbrush and tap the bristles up and down on the cookie to add texture.

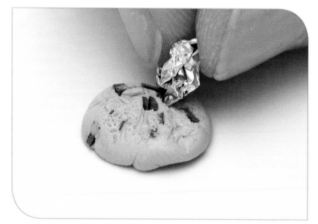

6 Crumple up some aluminum foil so it's as crinkly as possible. Press the foil into the top of your cookie to add lines and texture.

7 Once you're satisfied with the texture, use your blade tool to scrape a bit of the red-brown chalk pastel onto a piece of paper. Dust the powder on the top and bottom of your cookie to create a "baked" look.

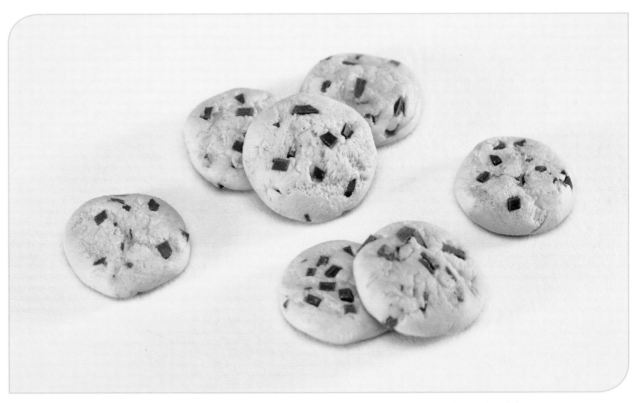

Try making different types of cookies by mixing up the colors and fillings. Use rainbow-colored chips or use brown clay for the dough to make chocolate cookies. Let your favorite cookies be your inspiration!

# chocolate cake

I have a soft spot for chocolate desserts, so making this cake is a fun way to satisfy my craving without the sugar!

.: what you will need :.

Dark brown clay

Brown clay

Red clay

Green clay

Beige or ecru clay

White clay

Translucent clay

Liquid polymer clay

Toothpick

Piercing tool or straight pin

Circle cutter, at least 1"
(2.5cm) in diameter

Small star cake tip

Clay roller

Mixing tool

Plastic or glass container

Blade

Ceramic tile or other
work surface

Glaze and paintbrush

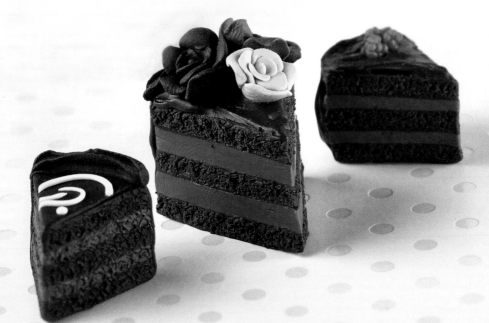

1 Roll out a sheet of dark brown clay about ¼" (6mm) thick, or if using a pasta machine, roll the clay through the widest setting. Cut out three circles with the circle cutter.

2 Repeat with brown clay and cut out two circles.

3 Stack the circles on top of each other, alternating the dark brown and light brown layers

**.: making circles without a cutter :.**
If you do not have a circle cutter, roll out three balls of dark brown clay of equal size and flatten them with a roller. Repeat with the light brown clay, but make only two circles.

4 Cut the stacked layers into six or eight equal slices, depending on the diameter of your circle. Separate all of the pieces so that you have individual triangles.

5 To create the fluffy texture of the cake, take your piercing tool or straight pin and make several crisscross lines on the two sides of the cake.

6 Using the end of your tool, start to "stir" the clay. The crisscross lines you made in step 5 should make it easier to create the fluffy texture.

7 The more stirred up the cake, the more realistic it looks, so stir as much as you like.

## FONDANT ICING

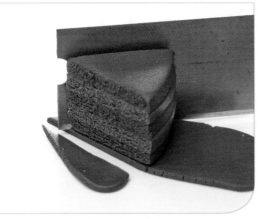

**1** Roll out a very thin sheet of dark brown clay, roughly the width of one slice of cake. Place the cake upside down on the sheet and cut the sheet to the size of the top of the cake.

**2** Move the slice so the back rests on the sheet, and cut away the sides and bottom. Your fondant should cover the top and back of the cake.

## FROSTING

**1** Place a bit of dark brown polymer clay and liquid polymer clay in a cup or container.

**2** Mix until you have a paste similar to real frosting. If your frosting is thick and difficult to work with, add more liquid. If it is runny, add a small amount of solid clay.

**3** Frost the top and back of the slice just like you would a real cake.

## PIPED BORDER

1 Mix a little bit of liquid clay into dark brown clay. Use just enough to make the mixture soft but not so sticky as to stick to your fingers.

2 Place the softened clay into a small star cake tip. Push down on the clay with the end of a paintbrush to squeeze it out.

3 Cut one long piece for a single border.

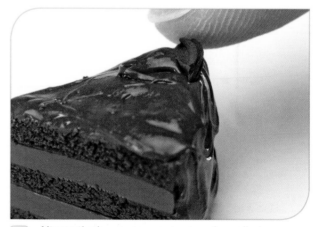

4 Place the border on top of the cake.

5 Alternatively, you can cut several small pieces, placing them in a row to form a border.

## PIPED DESIGN

1 Roll out very thin snakes of white clay.

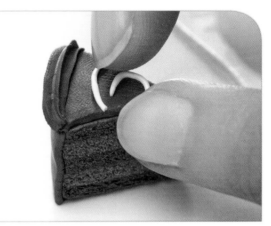

2 Arrange them onto the top of your cake in swirls or patterns. Play around with different patterns. You can even make piped words.

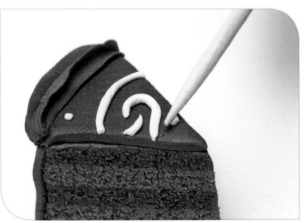

3 Use a toothpick to add tiny details like dots. Bake the piece and paint the frosting with glaze to make it shine.

1   To make a raspberry topping, mix red and translucent clay in a 1:1 ratio. Roll several tiny balls from this mix and place them together to form a bunch.

2   For the leaf, make a small flat circle out of green clay. Squeeze opposite sides of the clay between your thumb and index fingers to form a leaf. With the piercing tool, press lines in the middle of the leaf and a few branching out from the center.

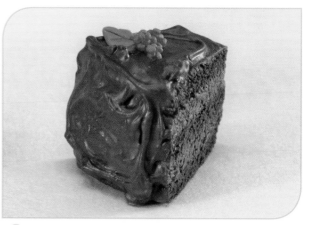

3   Arrange two or three bunches of red balls on the cake. Place the leaf next to the raspberries.

4   Bake the piece. When cool, paint the frosting with glaze to make it shine.

## ROSE DESIGN

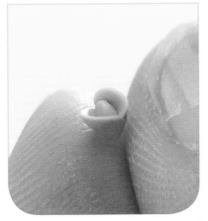

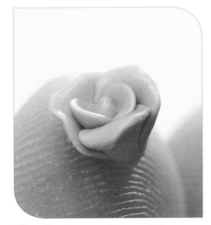

**1** Using ecru or beige clay, start a rose by making a small teardrop shape for the center. Take a ball of clay about the same size as the center and flatten it down into a triangle with rounded corners.

**2** Wrap this around the center of the rose. Take another flat petal and place it on the opposite side of the first petal.

**3** Continue making petals, progressively larger in size, and arrange them around your center until you're satisfied.

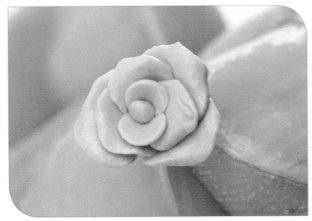

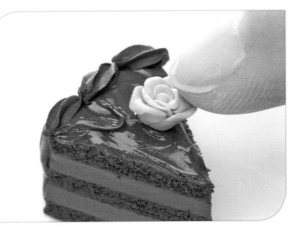

**4** Gently fold back the ends of the petals as you go to make them more realistic.

**5** Place the rose on the top of one of the cake slices. Bake the piece and paint the frosting with glaze to make it shine.

# designing your own pieces

Once you've tried your hand at working with polymer clay and you've gained some experience, designing your own pieces will become easier, and you will develop your own style. You'll want to keep in mind several basics when designing. The section below will give you a good place to start.

### Getting Started

Ideas and inspiration can come from anywhere, at any time. I keep a journal and pencil nearby at all times in case an idea comes to mind. Even everyday objects can be made into cute charms.

When I'm creating a new design, I look at the different colors that I have available, and I simply start kneading a piece of clay. Sometimes the piece of clay starts to look like something familiar; it's like seeing shapes in the clouds. If nothing comes to you, look through your idea journal or just start with something that you like or are familiar with.

Once you've chosen a subject, you can start making it cute! How do you do that? Take a look at the unicorn project as an example.

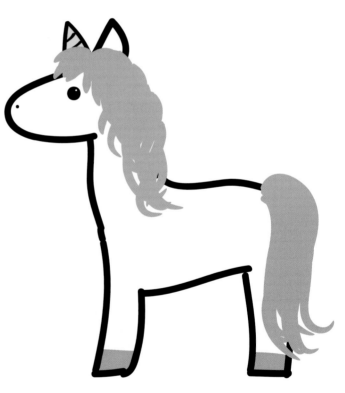

Start with a simple drawing of a unicorn design.

## Simplify

You need to simplify the animal by breaking it up into a few basic shapes. You can even start with a stick figure of the animal you're making. For this unicorn, the body and head are made into egg shapes, and the legs are all cylinders. Focus on the overall shape of the animal before looking at details. Look at the profile and see what features stand out.

Think about the shapes in relation to one another and where they connect. The places where the two parts touch will most likely be where you'll be smoothing or adding more clay. Unlike sculpting from one large chunk of clay, you're going to add clay to get the shape you want. To connect the head with the body, you need to add a cylinder between the two parts. This will be the neck. You'll smooth the legs onto the body where they connect.

## Add Details

Now that you have the basic shape, consider the details. Do you want to make details using clay or paint? Using clay to create details can sometimes be difficult, so for the unicorn you can paint on the hooves and eyes. On the other hand, painting the mane would be more time-consuming since you need to wait for the paint to dry between coats. In that case, you can use colored clay.

Work the details in layers. For the unicorn's mane, work from the bottom layer, which is touching the body. Once you have the whole bottom layer placed, add more on top. Working in layers allows you to cover any gaps or flaws that may be underneath.

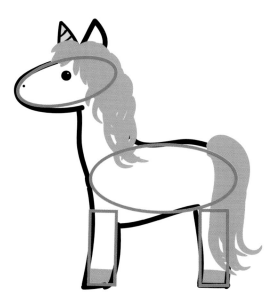

Break up the major components of the unicorn into simple shapes.

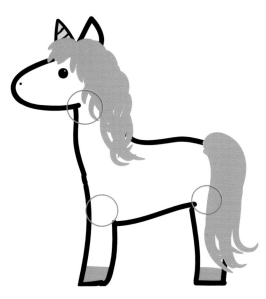

Identify the areas where pieces will need to be smoothed together. Here I circled them.

## Pick Colors

Even though there's no such thing as a blue elephant, it doesn't mean you can't make one! Don't be afraid to experiment with different colors. Use whatever colors you like best. Use markers, crayons or colored pencils to test out different color combinations without wasting clay.

If you want to add eyes, use a color that will make them stand out. When using darker colors of clay, like black or brown, for the face, it might be better to make white eyes rather than black.

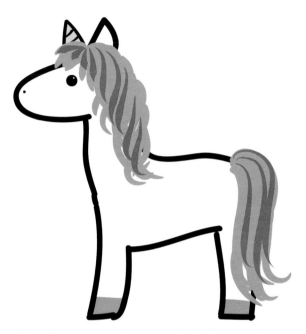

Start with a base layer (represented by the light pink), then add another layer on top (dark pink) to create more depth.

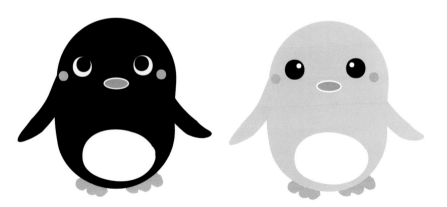

Achieve different looks by using different colors for the eyes.

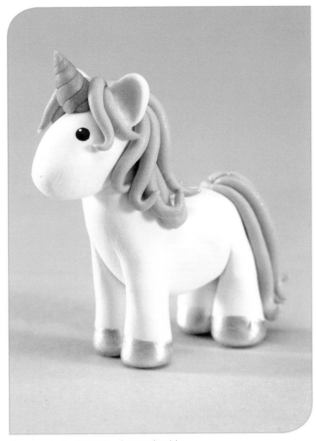

A completed unicorn in silver and gold.

## Things to Consider

Make all of the pieces of similar color at one time, then clean your hands before working with another color. This ensures that colors do not mix. In general, try working from light to dark colors.

What will the piece be for? Think about what the finished piece will be used for, and the risk of thin pieces breaking off. For example, if you will be making a key chain, make sure your design is a mostly solid piece with a lot of contact between things like arms and the body. Otherwise, you will have to reinforce any delicate parts with wire inside.

If you make a standing figure, choose a pose that is stable. If your piece is too top heavy, it won't stand properly. In that case, you can create a base out of clay or a piece of wood (just as long as it's something that can go into the oven).

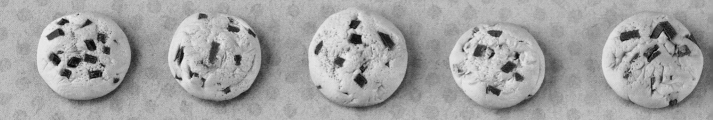

# resources

The tools and materials used in this book can be found at your local craft or hobby store. To learn more about a product or to find a retailer near you, contact the manufacturers listed below.

**.: polymer clay :.**

Staedtler | www.staedtler.com
FIMO polymer clay

Polyform Products | www.sculpey.com
Premo! Sculpey, Sculpey III, Translucent Liquid Sculpey, Sculpey Gloss Glaze

Van Aken | www.vanaken.com
Kato Polyclay

The Clay and Paint Factory S.A. | www.clay-and-paint.com
Cernit polymer clay

Craft Polymers | www.du-kit.com
Du-kit Make 'n' Bake

**.: acrylic paint :.**

Deco Art | decoart.com
Americana Acrylics

**.: glues/adhesives :.**

Gorilla Glue | www.gorillatough.com
Gorilla Super Glue

Eclectic Products, Inc. | eclecticproducts.com
E6000

# index

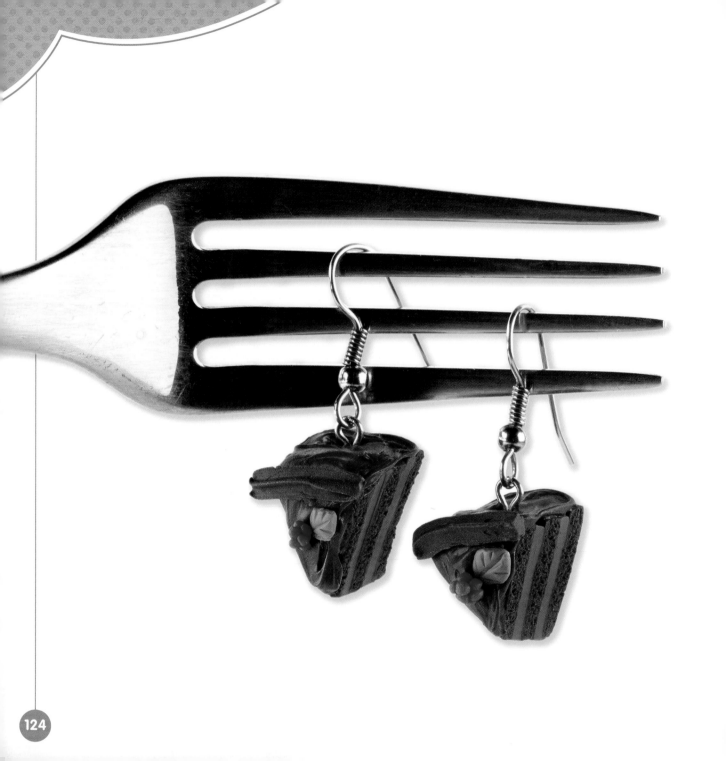

# acknowledgments

Thank you to my amazing editor and photographer, for working with me and for making this such a great experience, and to everyone from F+W, who helped make this book a reality. Lots of people have inspired me through-out the years, and I would like to give a shout-out to the deviantART community as a whole for bringing together so many amazing artists. I also couldn't have done this without the encouragement of my friends and family. Finally, thank you to all you readers for picking up this book!

# dedication

To Mom and Justin.

**Kawaii Polymer Clay Creations.**

Copyright © 2014 by Emily Chen. Manufactured in U.S.A. All rights reserved. No part of this book may be reproduced in any form or by any electronic or mechanical means including information storage and retrieval systems without permission in writing from the publisher, except by a reviewer who may quote brief passages in a review.

Published by Fons & Porter books, an imprint of F+W, a Content + eCommerce Company, 10151 Carver Road, Suite 200, Blue Ash, Ohio 45242. (800) 289-0963. First Edition.

Other fine Fons & Porter books are available from your favorite bookstore, fabric or craft store or online supplier. Visit our website at www.fwmedia.com.

18  17  16   5  4  3

ISBN-13: 978-1-4402-3973-1

SRN: U9839

DISTRIBUTED IN CANADA BY FRASER DIRECT
100 Armstrong Avenue
Georgetown, ON, Canada  L7G 5S4
Tel:  (905) 877-4411

DISTRIBUTED IN THE U.K. AND EUROPE
BY F&W MEDIA INTERNATIONAL
LTD Brunel House, Forde Close, Newton Abbot, TQ12 4PU, UK
Tel: (+44) 1626 323200, Fax: (+44) 1626 323319
Email: enquiries@fwmedia.com

DISTRIBUTED IN AUSTRALIA BY CAPRICORN LINK
P.O. Box 704, S. Windsor NSW, 2756 Australia
Tel: (02) 4560-1600     Fax: (02) 4577-5288
Email: books@capricornlink.com.au

Edited by Noel Rivera and Christine Doyle
Designed by Brianna Scharstein
Photography by Christine Polomsky and Al Parrish
Production coordinated by Greg Nock

| METRIC CONVERSION CHART | | |
|---|---|---|
| CONVERT......TO...........MULTIPLY BY | | |
| Inches | Centimeters | 2.54 |
| Centimeters | Inches | 0.4 |
| Feet | Centimeters | 30.5 |
| Centimeters | Feet | 0.03 |
| Yards | Meters | 0.9 |
| Meters | Yards | 1.1 |

# about
# the author

Emily Chen is a self-taught artist with a love for everything cute. She is currently living with her husband and a growing dog family in New Jersey. When she's not crafting cute things, Emily enjoys reading comics and fantasy books and watching funny cat videos. Visit her web site at www.catbearexpress.com.

*Cat Bear Express*

# More *kawaii*-inspired projects!

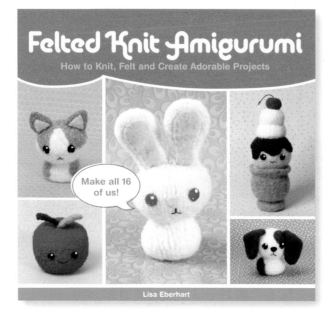

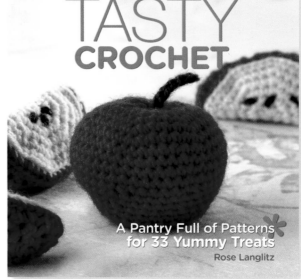

## Felted Knit Amigurumi
by Lisa Eberhart

Knit and felt your own cute collection of kittens, garden of cacti or assortment of robots with these 16 adorable amigurumi designs, perfect for making and sharing. Patterns include a puppy, rag doll kitten, goldfish, albino bunny, ferret, guinea pig, cactus, topiary, robot, sock monkey, stand mixer, apple, chocolate chip cookie, orange soda, cake slice and ice cream sundae. These *kawaii*-inspired projects are knitted with worsted weight, 100% wool yarn and hand felted for a super-cute, solid finish.

## Tasty Crochet
by Rose Langlitz

Whether you're craving peanuts or pizza, you'll find just the thing to hit the spot between the covers of *Tasty Crochet*. With over 30 crochet patterns on the menu, there's something here to please every palette. In addition to snack items that can be stitched up in a flash, you'll find patterns to plan a meal for breakfast, lunch, dinner and even dessert. The basic crochet techniques will get you started right away, and the short "ingredients" lists will make finishing an item quick and easy. You'll love increasing your daily fiber intake with *Tasty Crochet*!

## Visit www.interweave.com for more!